SIMPSONS

COMICS

SPECTACULAR

TITAN BOOKS

To the loving memory of Snowball I:
You may be gone, but the 30-lb. sack
of kibble you refused to eat remains
(out in the garage next to the paint cans).

SIMPSONS COMICS SPECTACULAR

Published in the UK by Titan Books, a division of Titan Publishing Group, 144 Southwark St.,
London, SE1 0UP, under licence from Bongo Entertainment, Inc.

FIRST EDITION: MARCH 2008

ISBN-10: 1 84576 736 5
ISBN-13: 9781845767365

2 4 6 8 10 9 7 5 3 1

Publisher: MATT GROENING
Managing Editor: JASON GRODE
Art Director - Editor: BILL MORRISON
Book Design: MARILYN FRANDSEN
Legal Guardian: SUSAN A. GRODE

Contributing Artists: BILL MORRISON, TIM BAVINGTON, PHIL ORTIZ, LUIS ESCOBAR,
STEPHANIE GLADDEN, STEVE VANCE, CINDY VANCE, NATHAN KANE

Contributing Writers: BILL MORRISON, ANDREW GOTTLIEB, GARY GLASBERG, STEVE VANCE

Printed in Spain

CONTENTS

GREETINGS, HUNGRY COMICS FANS!

Right this way, ladies and gentlemen, and welcome to another tasty all-you-can-eat collection of Simpsonoid comical funnies, written, penciled, inked, and simmered just for you by your favorite demented cartoon chefs at Bongo Comics. We've got a special meaty comic-book stew du jour a-bubblin' away on the stove for you this time, full of rich Barty goodness, thick Homerish chunks, and sinewy Lisa-esque fibers. And by popular request, we've added a scoop or two of spicy Maggie-reenos, along with our usual heaping dollops of authentic homemade Snowball II furballs, and, to stretch the meal even further, a jumbo boxful of Santa's Little Helper helper.

A Milhouse salad, of course, comes with every meal at no extra charge. Krustyburgers and Sideshow Mel fries are also available, but the extra-bitter Sideshow Bob soup is off the menu, at least temporarily.

And be sure to save room for dessert! You haven't lived 'til you've tasted a big old gooey bowl of Flanders-style flan, or munched on Mrs. Krabappel's famous crabapples, or chewed on a platterful of hot Itchy cakes drenched in creamy Scratchy sauce.

And if you clean your plate you get a special surprise! (The surprise being the surprised look on our faces that you actually cleaned your plate!)

So come on in, put up your feet, and start gnawing! We may not be the fanciest greasy-spoon hole-in-the-wall in town, but we stand by our slogan: "It's positively Simpslicious!"

What other book would even think of making that claim?

MATT GROENING
Bongo Comics Group

GIVE ME JUST 30 MINUTES AND I'LL MARK YOU FOR LIFE!

THE CELEBRITIES DO—WHY NOT YOU?

Do you want to be known as a man of the world? Do you want to be considered a woman of distinction? We've got what you're looking for! Nothing says "sophistication" like a tattoo of some soon-to-be-forgotten heavy metal band prominently emblazoned on your bicep. Nothing shouts "savoir faire" like a picture of your favorite cartoon character cavorting on your tush.

AMAZE YOUR FRIENDS—IMPRESS YOUR RIVALS!

At home–on the job–on the town– they won't believe their eyes when they see you brashly sporting the image of Krusty the Clown on your chest!

YOU GET THE BEST FOR LESS!

Each of our talented epidermal artists has completed a rigorous 45-minute training course before we turn 'em loose on the paying public.

YOU MUST BE AT LEAST 18 YEARS OLD OR BE ABLE TO LIE CONVINCINGLY. NOT RESPONSIBLE FOR MISSPELLINGS.

SPECIAL OFFER!

BUY ANY TWO OF THESE DESIGNS AT OUR REGULAR PRICE AND GET A THIRD TATTOO FREE!

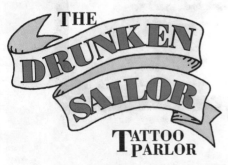

THE DRUNKEN SAILOR TATTOO PARLOR

NOT AFFILIATED WITH THE SOBER SAILOR TATTOO REMOVAL CLINIC.

"CHANGE OF HEART" 1/2 PRICE SALE!

When that love of a lifetime turns out to be a one-night stand, come to us. With our state-of-the-art retouching techniques, no one will ever know!

BEFORE

AFTER

LIMIT ONE PER CUSTOMER (WITH COUPON)

2ND LOCATION COMING SOON! TWO DOORS DOWN FROM MOE'S BAR!

BE-BOP-A-LISA

JUST AS I SUSPECTED -- MS. KRABAPPEL, TWO-TIMING ME WITH *GROUNDSKEEPER WILLIE*.

EXIT

SPRINGFIELD ELEMENTARY TALENT SHOW

≹GASP≹ *PRINCIPAL SKINNER!*

ACH! MIND YOUR OWN BUSINESS, YOU *DOILY-MAKIN' MAMA'S BOY!*

SCRIPT & PENCILS	INKS	COLORS	EDITOR	HEAD ROADIE
BILL MORRISON	*TIM BAVINGTON*	*CINDY VANCE*	*STEVE VANCE*	*MATT GROENING*

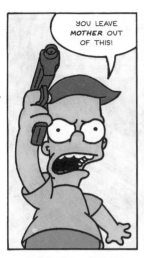

YOU LEAVE **MOTHER** OUT OF THIS!

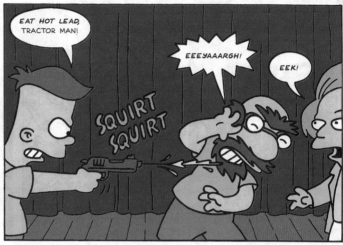

EAT HOT LEAD, TRACTOR MAN!

SQUIRT SQUIRT

EEEYAAARGH!

EEK!

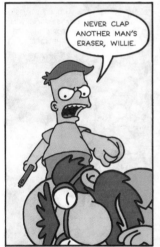

NEVER CLAP ANOTHER MAN'S ERASER, WILLIE.

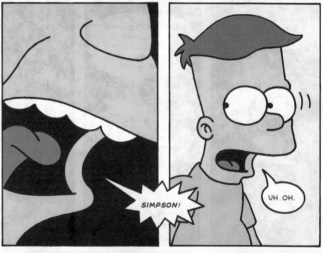

SIMPSON!

UH OH.

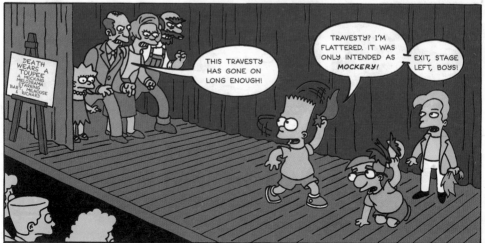

THIS TRAVESTY HAS GONE ON LONG ENOUGH!

TRAVESTY? I'M FLATTERED. IT WAS ONLY INTENDED AS **MOCKERY!**

EXIT, STAGE LEFT, BOYS!

DEATH WEARS A TOUPEE
A MOCKING MELODRAMA STARRING BART MILHOUSE & RICHARD

AS USUAL, BART HAS GIVEN ME A TOUGH ACT TO FOLLOW. WELL, YOU GOTTA PAY YOUR DUES IF YOU WANNA PLAY THE BLUES.

BLUES?!

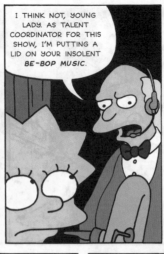

I THINK NOT, YOUNG LADY. AS TALENT COORDINATOR FOR THIS SHOW, I'M PUTTING A LID ON YOUR INSOLENT *BE-BOP MUSIC*.

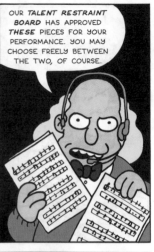

OUR *TALENT RESTRAINT BOARD* HAS APPROVED *THESE* PIECES FOR YOUR PERFORMANCE. YOU MAY CHOOSE FREELY BETWEEN THE TWO, OF COURSE.

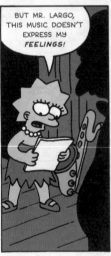

BUT MR. LARGO, THIS MUSIC DOESN'T EXPRESS MY *FEELINGS!*

WHAT ON EARTH DO *FEELINGS* HAVE TO DO WITH *MUSIC?* JUST GET OUT THERE AND *PLAY*.

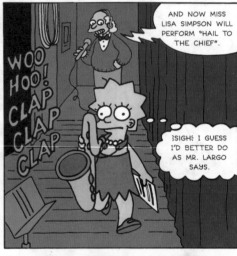

WOO HOO! CLAP CLAP CLAP

AND NOW MISS LISA SIMPSON WILL PERFORM "HAIL TO THE CHIEF".

SIGH I GUESS I'D BETTER DO AS MR. LARGO SAYS.

OH, BROTHER, IS THIS EVER LAME.

I SHOULDN'T HAVE *COMPROMISED.* I SHOULD HAVE REMAINED TRUE TO MY *ARTISTIC VISION.*

I MUST ACT *NOW,* WHILE THERE IS *STILL TIME!*

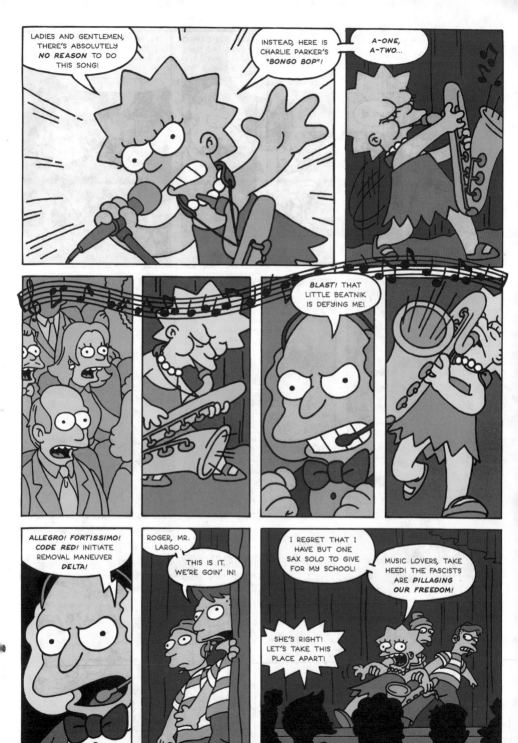

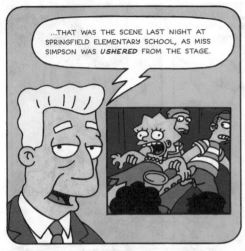

...THAT WAS THE SCENE LAST NIGHT AT SPRINGFIELD ELEMENTARY SCHOOL, AS MISS SIMPSON WAS *USHERED* FROM THE STAGE.

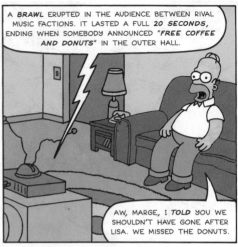

A *BRAWL* ERUPTED IN THE AUDIENCE BETWEEN RIVAL MUSIC FACTIONS. IT LASTED A FULL *20 SECONDS*, ENDING WHEN SOMEBODY ANNOUNCED *"FREE COFFEE AND DONUTS"* IN THE OUTER HALL.

AW, MARGE, I *TOLD* YOU WE SHOULDN'T HAVE GONE AFTER LISA. WE MISSED THE DONUTS.

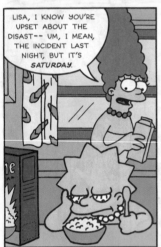

LISA, I KNOW YOU'RE UPSET ABOUT THE DISAST-- UM, I MEAN, THE INCIDENT LAST NIGHT, BUT IT'S *SATURDAY*.

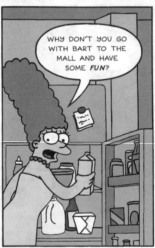

WHY DON'T YOU GO WITH BART TO THE MALL AND HAVE SOME *FUN*?

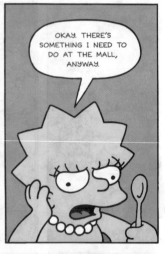

OKAY. THERE'S SOMETHING I NEED TO DO AT THE MALL, ANYWAY.

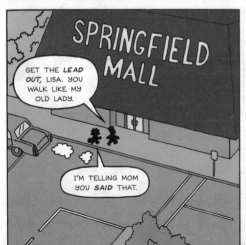

SPRINGFIELD MALL

GET THE *LEAD OUT*, LISA. YOU WALK LIKE MY OLD LADY.

I'M TELLING MOM YOU *SAID* THAT.

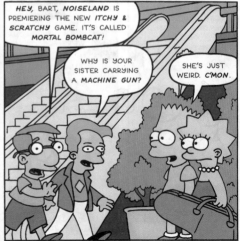

HEY, BART, *NOISELAND* IS PREMIERING THE NEW *ITCHY & SCRATCHY* GAME. IT'S CALLED *MORTAL BOMBCAT!*

WHY IS YOUR SISTER CARRYING A *MACHINE GUN*?

SHE'S JUST WEIRD. *C'MON*.

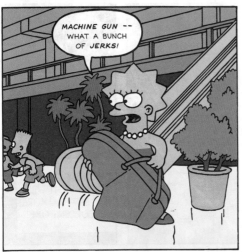

MACHINE GUN -- WHAT A BUNCH OF JERKS!

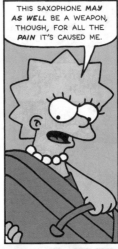

THIS SAXOPHONE *MAY AS WELL* BE A WEAPON, THOUGH, FOR ALL THE *PAIN* IT'S CAUSED ME.

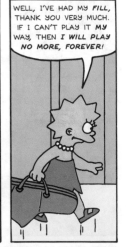

WELL, I'VE HAD MY *FILL*, THANK YOU VERY MUCH. IF I CAN'T PLAY IT *MY* WAY, THEN *I WILL PLAY NO MORE, FOREVER!*

I HOPE MR. KRANZ AT *KING TOOTS MUSIC STORE* CAN USE A GOOD, PREVIOUSLY-OWNED *SAXOPHONE.*

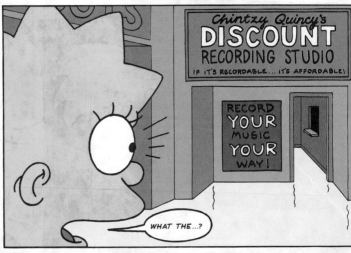

Chintzy Quincy's
DISCOUNT
RECORDING STUDIO
IF IT'S RECORDABLE... IT'S AFFORDABLE!

RECORD YOUR MUSIC YOUR WAY!

WHAT THE...?

WOW! A RECORDING STUDIO! I CAN JAM *ONE* LAST TIME AND TAPE IT FOR *POSTERITY.*

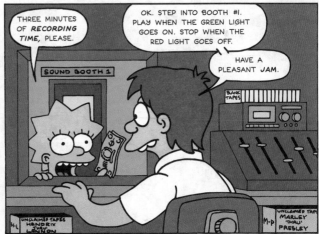

THREE MINUTES OF *RECORDING TIME,* PLEASE.

OK. STEP INTO BOOTH #1. PLAY WHEN THE GREEN LIGHT GOES ON. STOP WHEN THE RED LIGHT GOES OFF.

HAVE A PLEASANT JAM.

SOUND BOOTH 1

BLANK TAPES

UNCLAIMED TAPES HENDRIX THRU LENNON

H-L

M-P

UNCLAIMED TAP MARLEY THRU PRESLEY

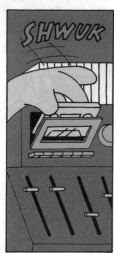

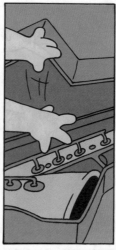

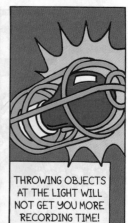

THROWING OBJECTS AT THE LIGHT WILL NOT GET YOU MORE RECORDING TIME!

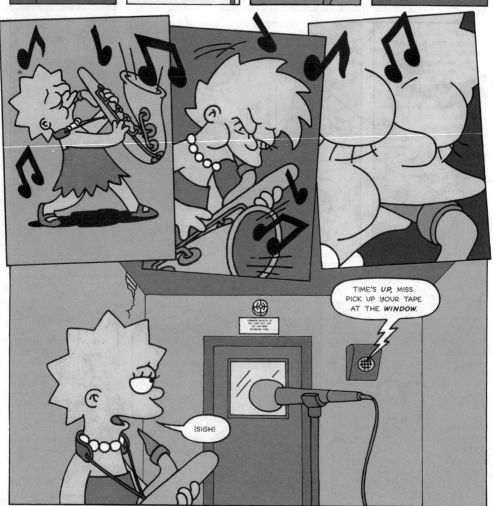

TIME'S *UP*, MISS. PICK UP YOUR TAPE AT THE *WINDOW.*

ƎSIGH£

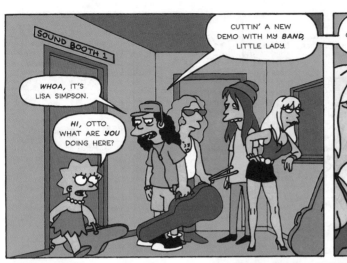

SOUND BOOTH 1

WHOA, IT'S LISA SIMPSON.

HI, OTTO. WHAT ARE *YOU* DOING HERE?

CUTTIN' A NEW DEMO WITH MY *BAND*, LITTLE LADY.

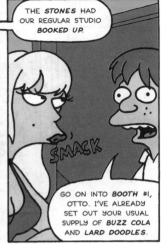

THE *STONES* HAD OUR REGULAR STUDIO *BOOKED UP*.

SMACK

GO ON INTO *BOOTH* #1, OTTO. I'VE ALREADY SET OUT YOUR USUAL SUPPLY OF *BUZZ COLA* AND *LARD DOODLES*.

AMAZING -- IT JUST TAKES A COUPLE OF WINKS TO GET US DISCOUNT RECORDING TIME!

⟨GULP⟩ I'LL SET UP YOUR TAPE AS SOON AS I'VE FINISHED WITH THE LITTLE GIRL.

⟨GULP⟩

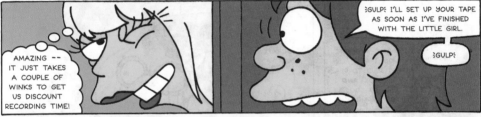

CLICK!

EXCUSE ME, SIR. MAY I HAVE MY *TAPE*, PLEASE?

HUH? OH, SURE.

...I'VE GOT IT RIGHT HERE.

BLANK TAPES

THERE YOU GO.

THANKS.

DON'T MENTION IT.

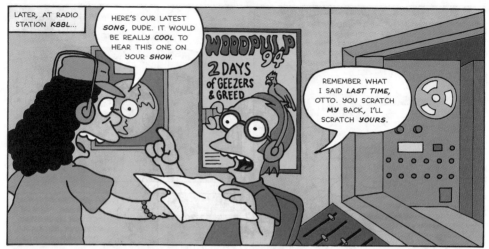

LATER, AT RADIO STATION *KBBL*...

HERE'S OUR LATEST *SONG*, DUDE. IT WOULD BE REALLY *COOL* TO HEAR THIS ONE ON YOUR *SHOW*.

WOODPULP '94
2 DAYS of GEEZERS & GREED

REMEMBER WHAT I SAID *LAST TIME*, OTTO. YOU SCRATCH *MY* BACK, I'LL SCRATCH *YOURS*.

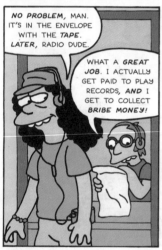

NO PROBLEM, MAN. IT'S IN THE ENVELOPE WITH THE *TAPE*. *LATER*, RADIO DUDE.

WHAT A *GREAT JOB*. I ACTUALLY GET PAID TO PLAY RECORDS, *AND* I GET TO COLLECT *BRIBE MONEY!*

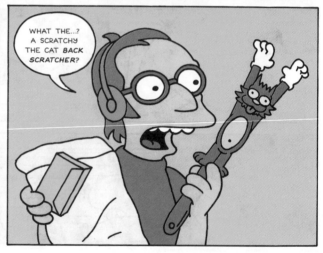

WHAT THE...? A SCRATCHY THE CAT *BACK SCRATCHER?*

:SIGH: HE *JUST* DOESN'T GET IT.

Green Stuff
PRE-PACKAGED SALAD BITS
SUGARY WAMPUM CEREAL
PAYOLA CANDY BAR
BREAD

FROM OTTO

OH, WELL, I MAY AS WELL PLAY THE *TAPE*. OTTO'S SONGS ARE *ALWAYS* GOOD FOR A LAUGH.

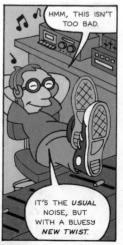

HMM, THIS ISN'T TOO BAD.

IT'S THE *USUAL* NOISE, BUT WITH A BLUESY *NEW TWIST*.

A UNIQUE NEW BLEND OF *SPEED METAL* AND

SPEED JAZZ!

NO, WAIT -- *SPAZZ!*

MEANWHILE...

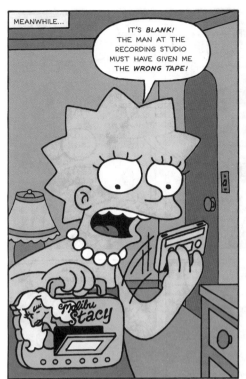

IT'S *BLANK!* THE MAN AT THE RECORDING STUDIO MUST HAVE GIVEN ME THE *WRONG TAPE!*

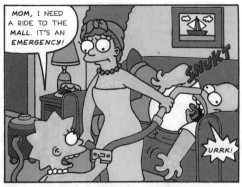

MOM, I NEED A RIDE TO THE *MALL.* IT'S AN *EMERGENCY!*

SNUKT

URRK!

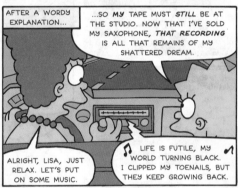

AFTER A WORDY EXPLANATION...

...SO *MY* TAPE MUST *STILL* BE AT THE STUDIO. NOW THAT I'VE SOLD MY SAXOPHONE, *THAT RECORDING* IS ALL THAT REMAINS OF MY SHATTERED DREAM.

ALRIGHT, LISA, JUST RELAX. LET'S PUT ON SOME MUSIC.

LIFE IS FUTILE, MY WORLD TURNING BLACK. I CLIPPED MY TOENAILS, BUT THEY KEEP GROWING BACK.

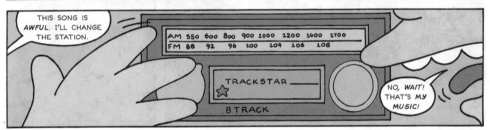

THIS SONG IS *AWFUL.* I'LL CHANGE THE STATION.

AM 550 600 800 900 1000 1200 1400 1700
FM 88 92 96 100 104 106 108

TRACKSTAR

8 TRACK

NO, *WAIT!* THAT'S *MY MUSIC!*

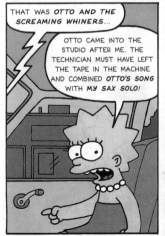

THAT WAS *OTTO AND THE SCREAMING WHINERS...*

OTTO CAME INTO THE STUDIO AFTER ME. THE TECHNICIAN MUST HAVE LEFT THE TAPE IN THE MACHINE AND COMBINED *OTTO'S SONG* WITH *MY SAX SOLO!*

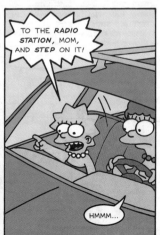

TO THE *RADIO STATION,* MOM, AND *STEP* ON IT!

HMMM...

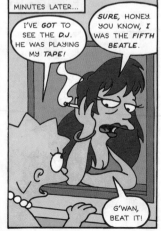

MINUTES LATER...

I'VE *GOT* TO SEE THE *DJ.* HE WAS PLAYING MY *TAPE!*

SURE, HONEY. YOU KNOW, *I* WAS THE *FIFTH BEATLE.*

G'WAN, BEAT IT!

17

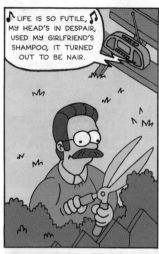

THEY CALL IT *SPAZZ* MUSIC, AND IT HAS TAKEN MUSIC CRITICS AND FANS *ALIKE* BY *STORM*.

EVEN THE *JAZZ HOLE*, SPRINGFIELD'S *OLDEST* CULTURAL ESTABLISHMENT, IS GETTING WITH THE PROGRAM.

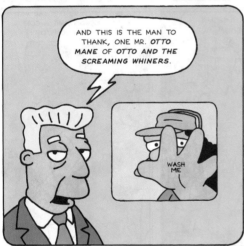

AND THIS IS THE MAN TO THANK, ONE MR. *OTTO MANE* OF *OTTO AND THE SCREAMING WHINERS*.

WASH ME

IT IS *HE ALONE* WHO IS RESPONSIBLE FOR THE HIT SONG "*SMELLS LIKE FUTILITY*", WHICH LAUNCHED *SPAZZMANIA*.

OTTO AND HIS BAND MAY BE SEEN *PERFORMING* THE MONSTER HIT AT THE *SPRINGFIELD COLLISEUM* TOMORROW NIGHT, AS THEY KICK OFF THEIR BIG TRI-COUNTY *FUTILITY TOUR*.

FIRST MY PLAYING WAS MET WITH *CENSORSHIP AND HUMILIATION*. *NOW* IT'S RESPONSIBLE FOR A *MEGA-HIT RECORD*, AND NOBODY WILL *BELIEVE* ME.

I THINK IT'S TIME I HAD *WORDS* WITH A CERTAIN FORMER *BUS DRIVER*.

THE FOLLOWING EVENING, AT THE COLISEUM...

THANKS FOR **DRIVING** US, DAD. DON'T FORGET TO PICK US UP AT TEN. YOU'LL REMEMBER THE **LOCATION**, WON'T YOU?

YEAH, YEAH. SPRINGFIELD MAUSOLEUM. **SEE YA!**

MUST GET TO MOE'S -- IT'S PICKLED OKRA NIGHT!

OTTO AND THE
SCREAMING WHINERS
ALSO
SAX-MANIA
A TRIBUTE TO BOOTS RANDOLPH

COUGH COUGH HACK!

I HOPE YOU FEEL UP TO **WALKING** HOME, BART.

SCREEEE

INSIDE...

WE'RE JUST IN TIME.

AFTER THE CONCERT, I'LL **CONFRONT** OTTO AND GET HIM TO ADMIT THE **TRUTH**.

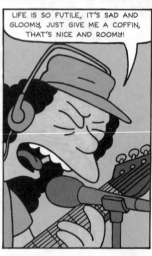

LIFE IS SO FUTILE, IT'S SAD AND GLOOMY, JUST GIVE ME A COFFIN, THAT'S NICE AND ROOMY!

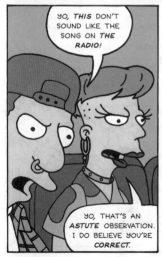

YO, **THIS** DON'T SOUND LIKE THE SONG ON **THE RADIO!**

YO, THAT'S AN **ASTUTE** OBSERVATION. I DO BELIEVE YOU'RE **CORRECT**.

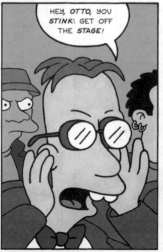

HEY, **OTTO**, YOU **STINK!** GET OFF THE **STAGE!**

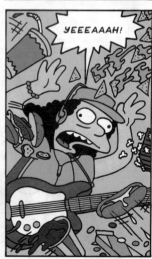

YEEEAAAH!

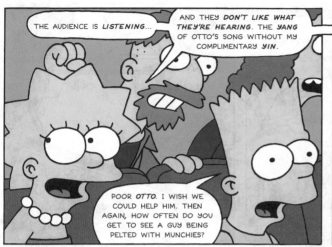

THE AUDIENCE IS *LISTENING*...

AND THEY *DON'T LIKE WHAT THEY'RE HEARING.* THE *YANG* OF OTTO'S SONG WITHOUT MY COMPLIMENTARY *YIN*.

POOR *OTTO.* I WISH WE COULD HELP HIM. THEN AGAIN, HOW OFTEN DO YOU GET TO SEE A GUY BEING PELTED WITH MUNCHIES?

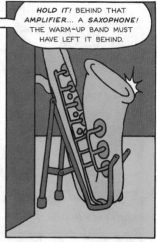

HOLD IT! BEHIND THAT *AMPLIFIER*... A *SAXOPHONE!* THE WARM-UP BAND MUST HAVE LEFT IT BEHIND.

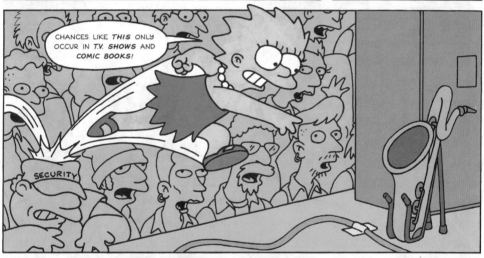

CHANCES LIKE *THIS* ONLY OCCUR IN *T.V. SHOWS* AND *COMIC BOOKS!*

SECURITY

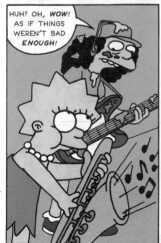

HUH? OH, *WOW!* AS IF THINGS WEREN'T BAD *ENOUGH!*

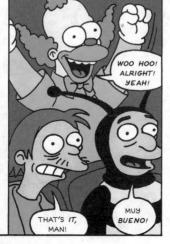

WOO HOO! ALRIGHT! YEAH!

THAT'S *IT*, MAN!

MUY *BUENO!*

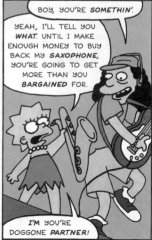

BOY, YOU'RE *SOMETHIN'.*

YEAH, I'LL TELL YOU *WHAT.* UNTIL I MAKE ENOUGH MONEY TO BUY BACK MY *SAXOPHONE*, YOU'RE GOING TO GET MORE THAN YOU *BARGAINED* FOR.

I'M YOU'RE DOGGONE *PARTNER!*

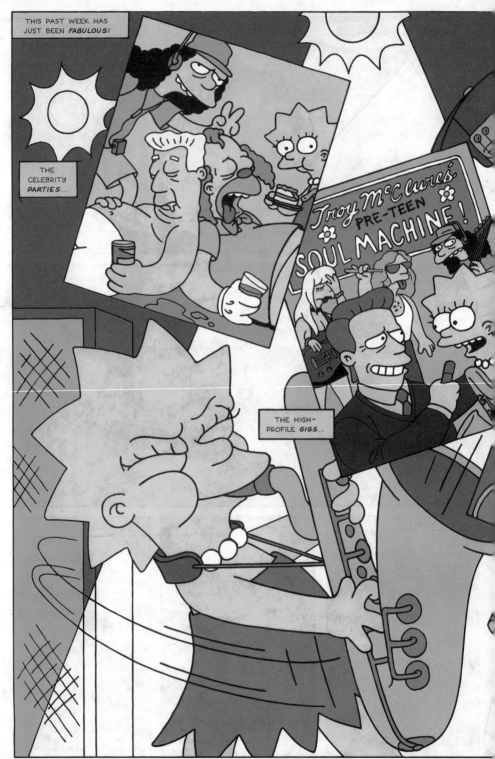

THIS PAST WEEK HAS JUST BEEN *FABULOUS!*

THE CELEBRITY *PARTIES*...

THE HIGH-PROFILE *GIGS*...

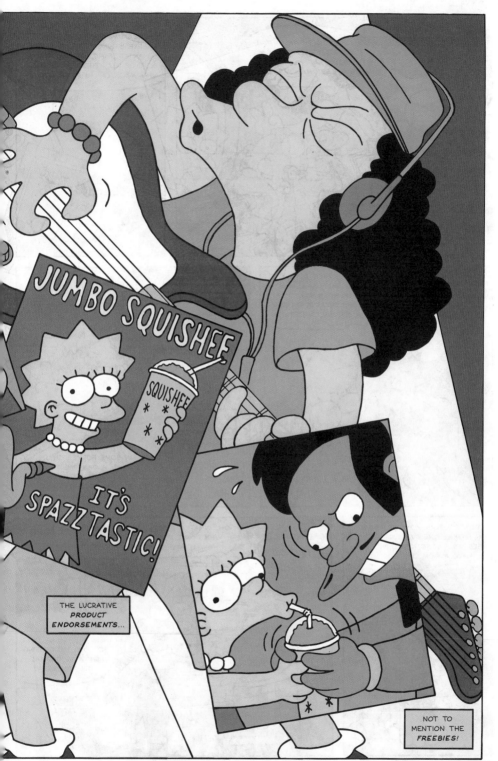

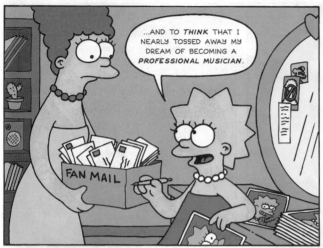

...AND TO *THINK* THAT I NEARLY TOSSED AWAY MY DREAM OF BECOMING A *PROFESSIONAL MUSICIAN*.

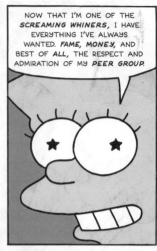

NOW THAT I'M ONE OF THE *SCREAMING WHINERS*, I HAVE EVERYTHING I'VE ALWAYS WANTED. *FAME*, *MONEY*, AND BEST OF *ALL*, THE RESPECT AND ADMIRATION OF MY *PEER GROUP*.

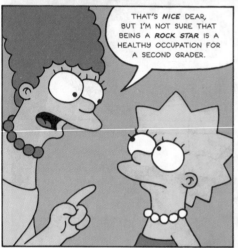

THAT'S *NICE* DEAR, BUT I'M NOT SURE THAT BEING A *ROCK STAR* IS A HEALTHY OCCUPATION FOR A SECOND GRADER.

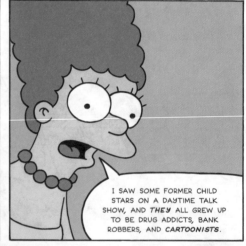

I SAW SOME FORMER CHILD STARS ON A DAYTIME TALK SHOW, AND *THEY* ALL GREW UP TO BE DRUG ADDICTS, BANK ROBBERS, AND *CARTOONISTS*.

DON'T WORRY MOM. *I* CAN HANDLE THE PRESSURE. BESIDES, *THOSE* KIDS DIDN'T HAVE A MOM LIKE *YOU*.

OH, WHAT A *SWEET* THING TO SAY. NOW WHY DON'T YOU PUT THOSE PICTURES AWAY, AND GET READY FOR BED?

YOU'RE *RIGHT*. I NEED PLENTY OF REST FOR OUR BIG CLOSING SHOW IN *CAPITAL CITY* TOMORROW.

THE NEXT EVENING, AT THE MEGA-DOME IN CAPITAL CITY...

THE HOUSE IS REALLY FILLING UP, OTTO.

I THINK I SEE SOME *VERY BIG PEOPLE* IN THE FRONT ROW.

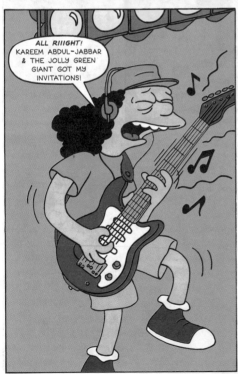

ALL RIIIGHT! KAREEM ABDUL-JABBAR & THE JOLLY GREEN GIANT GOT MY INVITATIONS!

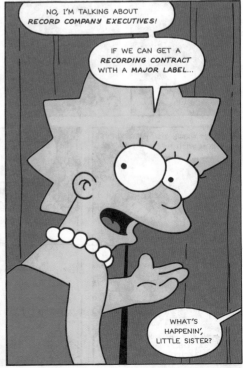

NO, I'M TALKING ABOUT *RECORD COMPANY EXECUTIVES!*

IF WE CAN GET A *RECORDING CONTRACT* WITH A *MAJOR LABEL...*

WHAT'S HAPPENIN', LITTLE SISTER?

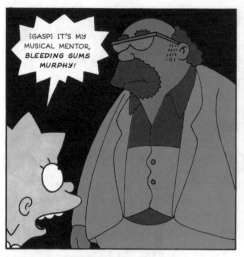

:GASP: IT'S MY MUSICAL MENTOR, *BLEEDING GUMS MURPHY!*

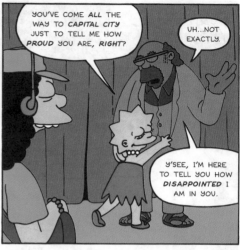

YOU'VE COME *ALL THE WAY* TO *CAPITAL CITY* JUST TO TELL ME HOW *PROUD YOU ARE, RIGHT?*

UH...NOT *EXACTLY.*

Y'SEE, I'M HERE TO TELL YOU HOW *DISAPPOINTED* I AM IN YOU.

YOUR MUSIC *USED* TO HAVE SO MUCH *SOUL,* BUT NOW IT SEEMS TO ME THAT YOU JUS' *SOLD OUT!*

SURE, YOU GOT *FAME* AND *MONEY,* BUT WHAT GOOD IS ALL *THAT* IF YOU AIN'T TRUE TO YOUR *ARTISTIC VISION?*

WOW. YOU'RE *RIGHT.* IT'S ALL SO *CLEAR* NOW. OTTO'S MUSIC WAS NEVER *RIGHT* FOR ME. I'VE JUST BEEN *USING* THIS OPPORTUNITY TO GAIN THE ACCEPTANCE I'VE ALWAYS DESIRED.

OTTO, I KNOW THIS IS *LAST MINUTE,* BUT TO SALVAGE MY SELF-RESPECT, I'M GOING TO HAVE TO *QUIT THE BAND.*

THAT'S *BOGUS!* WHAT'LL WE DO WITHOUT A *HORN PLAYER?*

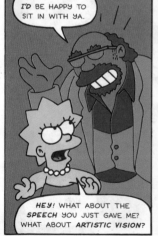

I'D BE HAPPY TO SIT IN WITH YA.

HEY! WHAT ABOUT THE *SPEECH* YOU JUST GAVE ME? WHAT ABOUT *ARTISTIC VISION?*

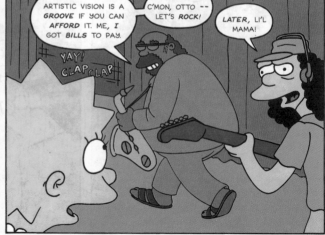

ARTISTIC VISION IS A *GROOVE* IF YOU CAN *AFFORD* IT. ME, *I* GOT *BILLS* TO PAY.

C'MON, OTTO -- LET'S *ROCK!*

LATER, LI'L MAMA!

YAY! CLAP CLAP

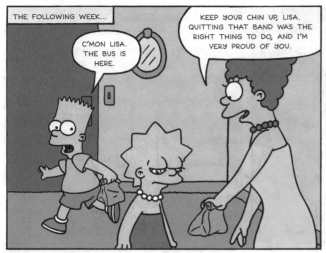

C'MON LISA. THE BUS IS HERE.

KEEP YOUR CHIN UP, LISA. QUITTING THAT BAND WAS THE RIGHT THING TO DO, AND I'M VERY PROUD OF YOU.

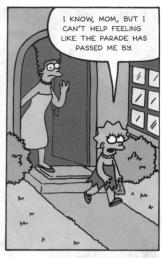

I KNOW, MOM, BUT I CAN'T HELP FEELING LIKE THE PARADE HAS PASSED ME BY.

OTTO! WHAT ARE YOU DOING DRIVING THE BUS AGAIN?

WE TALKED TO THOSE RECORD COMPANY DUDES AFTER THE SHOW. THEY TOLD US SPAZZ IS *OUT*. THE NEW THING IS THIS FUSION OF *RAP* AND *MAMBO*.

IT'S CALLED *"RAMBO."*

WE TRIED TO GET INTO IT, BUT THOSE AMMO BELTS KEPT GETTING CAUGHT ON MY *WHAMMY BAR!*

WELL, IT WAS GREAT WHILE IT LASTED.

YOU CAN STILL BLOW A *MEAN SAX*, LITTLE LADY.

HEY, OTTO MAN. LET'S GET THIS HEAP O' JUNK *MOVIN'!*

RIGHT YOU ARE, BART DUDE! LET'S *ROCK & ROLL!*

THE END!

"THE END OF EL BARTO"

SCRIPT & PENCILS: *STEVE VANCE*

INKS: *BAVINGTON & VANCE*

COLORS: *CINDY VANCE*

BAILIFF: *MATT GROENING*

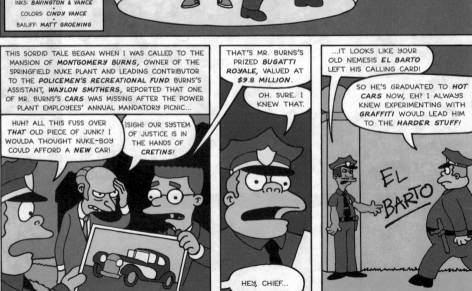

THIS SORDID TALE BEGAN WHEN I WAS CALLED TO THE MANSION OF *MONTGOMERY BURNS*, OWNER OF THE SPRINGFIELD NUKE PLANT AND LEADING CONTRIBUTOR TO THE *POLICEMEN'S RECREATIONAL FUND*. BURNS'S ASSISTANT, *WAYLON SMITHERS*, REPORTED THAT ONE OF MR. BURNS'S *CARS* WAS MISSING AFTER THE POWER PLANT EMPLOYEES' ANNUAL MANDATORY PICNIC...

HUH? ALL THIS FUSS OVER *THAT* OLD PIECE OF JUNK? I WOULDA THOUGHT NUKE-BOY COULD AFFORD A *NEW* CAR!

SIGH OUR SYSTEM OF JUSTICE IS IN THE HANDS OF *CRETINS!*

THAT'S MR. BURNS'S PRIZED *BUGATTI ROYALE*, VALUED AT *$9.8 MILLION.*

OH. SURE. I KNEW THAT.

HEY, CHIEF...

...IT LOOKS LIKE YOUR OLD NEMESIS *EL BARTO* LEFT HIS CALLING CARD!

SO HE'S GRADUATED TO *HOT CARS* NOW, EH? I ALWAYS KNEW EXPERIMENTING WITH *GRAFFITI* WOULD LEAD HIM TO THE *HARDER STUFF!*

EL BARTO

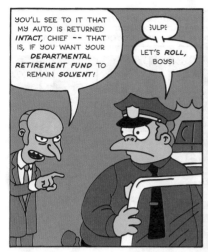

YOU'LL SEE TO IT THAT MY AUTO IS RETURNED *INTACT*, CHIEF -- THAT IS, IF YOU WANT YOUR *DEPARTMENTAL RETIREMENT FUND* TO REMAIN *SOLVENT*!

ʒULPʒ

LET'S *ROLL*, BOYS!

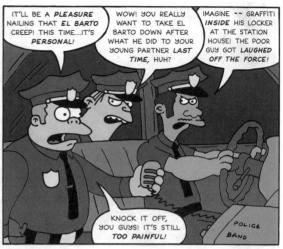

IT'LL BE A *PLEASURE* NAILING THAT *EL BARTO* CREEP! THIS TIME...IT'S *PERSONAL*!

WOW! YOU REALLY WANT TO TAKE EL BARTO DOWN AFTER WHAT HE DID TO YOUR YOUNG PARTNER *LAST TIME*, HUH?

IMAGINE -- GRAFFITI *INSIDE* HIS LOCKER AT THE STATION HOUSE! THE POOR GUY GOT *LAUGHED OFF THE FORCE*!

KNOCK IT OFF, YOU GUYS! IT'S STILL *TOO PAINFUL*!

POLICE BAND

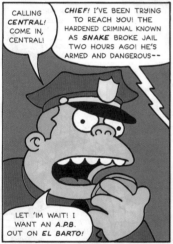

CALLING *CENTRAL*! COME IN, CENTRAL!

CHIEF! I'VE BEEN TRYING TO REACH YOU! THE HARDENED CRIMINAL KNOWN AS *SNAKE* BROKE JAIL TWO HOURS AGO! HE'S ARMED AND DANGEROUS--

LET 'IM WAIT! I WANT AN *A.P.B.* OUT ON *EL BARTO*!

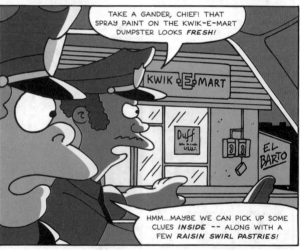

TAKE A GANDER, CHIEF! THAT SPRAY PAINT ON THE KWIK-E-MART DUMPSTER LOOKS *FRESH*!

KWIK E MART

Duff

EL BARTO

HMM...MAYBE WE CAN PICK UP SOME CLUES *INSIDE* -- ALONG WITH A FEW *RAISIN SWIRL PASTRIES*!

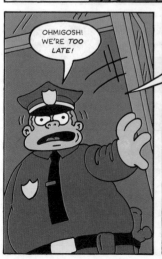

OHMIGOSH! WE'RE *TOO LATE*!

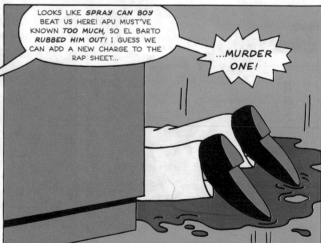

LOOKS LIKE *SPRAY CAN BOY* BEAT US HERE! APU MUST'VE KNOWN *TOO MUCH*, SO EL BARTO *RUBBED HIM OUT*! I GUESS WE CAN ADD A NEW CHARGE TO THE RAP SHEET...

...MURDER ONE!

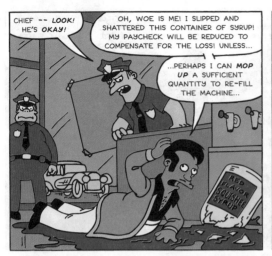

CHIEF -- *LOOK!* HE'S *OKAY!*

OH, WOE IS ME! I SLIPPED AND SHATTERED THIS CONTAINER OF SYRUP! MY PAYCHECK WILL BE REDUCED TO COMPENSATE FOR THE LOSS! UNLESS...

...PERHAPS I CAN *MOP UP* A SUFFICIENT QUANTITY TO RE-FILL THE MACHINE...

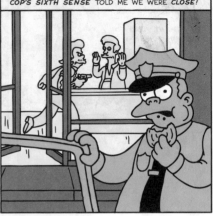

WE HEADED OUT INTO THE NIGHT AGAIN. THE KWIK-E-MART HAD YIELDED NO NEW LEADS, BUT MY *COP'S SIXTH SENSE* TOLD ME WE WERE *CLOSE!*

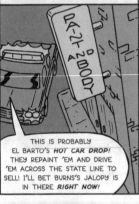

WE HIT THE ALL-NIGHT HARDWARE STORE TO SEE IF THERE HAD BEEN ANY UNUSUAL *PAINT PURCHASES* THIS EVENING. THIS LED US TO A NEARBY AUTO BODY SHOP...

THIS IS PROBABLY EL BARTO'S *HOT CAR DROP!* THEY REPAINT 'EM AND DRIVE 'EM ACROSS THE STATE LINE TO SELL! I'LL BET BURNS'S JALOPY IS IN THERE *RIGHT NOW!*

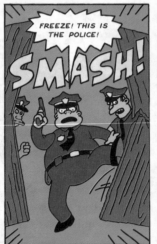

FREEZE! *THIS IS THE POLICE!*

SMASH!

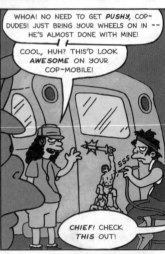

WHOA! NO NEED TO GET *PUSHY,* COP-DUDES! JUST BRING YOUR WHEELS ON IN -- HE'S ALMOST DONE WITH MINE!

COOL, HUH? THIS'D LOOK *AWESOME* ON YOUR COP-MOBILE!

CHIEF! CHECK *THIS OUT!*

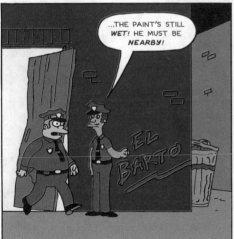

...THE PAINT'S STILL *WET!* HE MUST BE *NEARBY!*

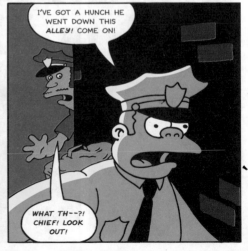

I'VE GOT A HUNCH HE WENT DOWN THIS *ALLEY!* COME ON!

WHAT TH--?! CHIEF! *LOOK OUT!*

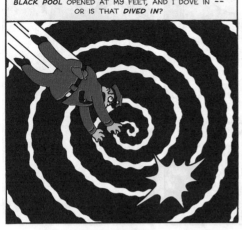

SUDDENLY, THE WORLD TURNED UPSIDE-DOWN. A *BLACK POOL* OPENED AT MY FEET, AND I DOVE IN -- OR IS THAT *DIVED IN*?

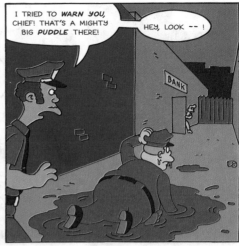

I TRIED TO *WARN YOU*, CHIEF! THAT'S A MIGHTY BIG *PUDDLE* THERE!

HEY, LOOK -- !

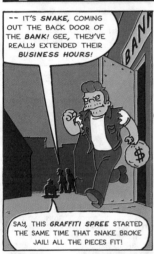

-- IT'S *SNAKE*, COMING OUT THE BACK DOOR OF THE *BANK*! GEE, THEY'VE REALLY EXTENDED THEIR *BUSINESS HOURS*!

SAY, THIS *GRAFFITI SPREE* STARTED THE SAME TIME THAT SNAKE BROKE JAIL! ALL THE PIECES FIT!

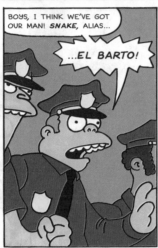

BOYS, I THINK WE'VE GOT OUR MAN! *SNAKE*, ALIAS...

...*EL BARTO!*

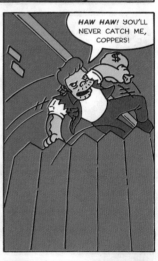

HAW HAW! YOU'LL NEVER CATCH ME, COPPERS!

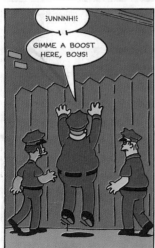

ÉUNNNHÌ

GIMME A BOOST HERE, BOYS!

HEY!

OOOF!

OWW!

TAK TAK

OKAY -- I'VE GOT A BETTER IDEA.

LET'S GO AROUND THE BLOCK AND CUT HIM OFF!

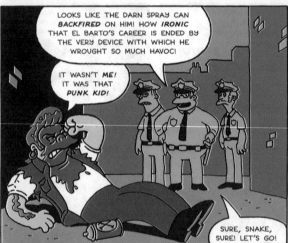

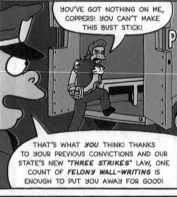

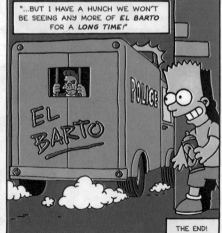

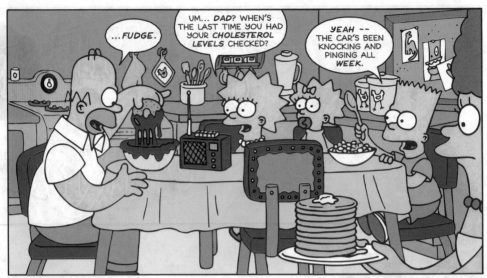

...FUDGE.

UM... DAD? WHEN'S THE LAST TIME YOU HAD YOUR CHOLESTEROL LEVELS CHECKED?

YEAH -- THE CAR'S BEEN KNOCKING AND PINGING ALL WEEK.

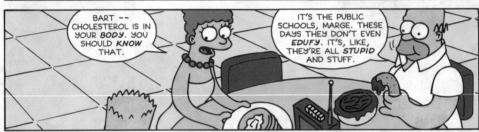

BART -- CHOLESTEROL IS IN YOUR BODY. YOU SHOULD KNOW THAT.

IT'S THE PUBLIC SCHOOLS, MARGE. THESE DAYS THEY DON'T EVEN EDUFY. IT'S, LIKE, THEY'RE ALL STUPID AND STUFF.

HEY THERE! THIS IS BILL AND MARTY ON KBBL RADIO! THIS JUST IN: THE SILENT PARTNER AND WOLFCASTLE & KRUSTOFSKI CIRCUS IS COMING TO TOWN! IN FACT, THEY GOT HERE HALF AN HOUR AGO. SO RUN, DON'T WALK, TO THE SPRINGFIELD FAIRGROUNDS. THE FIRST 200 PAYING SUCKERS... ER, CUSTOMERS -- WILL RECEIVE COMPLIMENTARY "STAMPY THE ELEPHANT" PLASTIC DUNG SHOVELS.

THE CIRCUS!

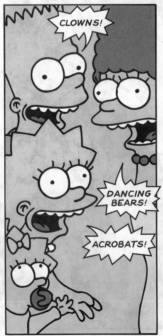

CLOWNS!

DANCING BEARS!

ACROBATS!

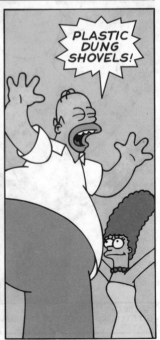

PLASTIC DUNG SHOVELS!

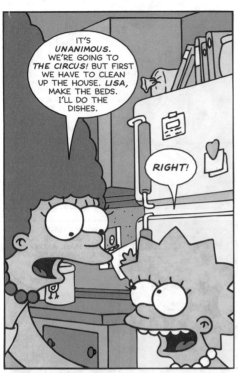

IT'S *UNANIMOUS.* WE'RE GOING TO *THE CIRCUS!* BUT FIRST WE HAVE TO CLEAN UP THE HOUSE. *LISA,* MAKE THE BEDS. I'LL DO THE DISHES.

RIGHT!

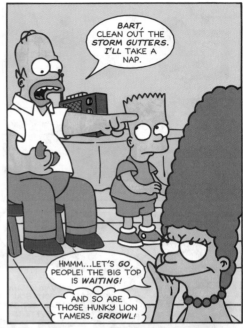

BART, CLEAN OUT THE *STORM GUTTERS. I'LL TAKE A NAP.*

HMMM...LET'S *GO,* PEOPLE! THE BIG TOP IS *WAITING!*

AND SO ARE THOSE HUNKY LION TAMERS. *GRROWL!*

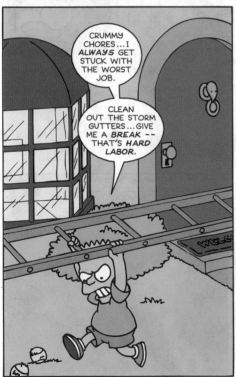

CRUMMY CHORES...I *ALWAYS* GET STUCK WITH THE WORST JOB.

CLEAN OUT THE STORM GUTTERS...GIVE ME A *BREAK --* THAT'S *HARD* LABOR.

SHWEE!!

HUH-*WEE!*

SANTA'S LITTLE HELPER'S CHEWBALLS. DOG SPIT -- *GROSS.* OH, WELL, BACK TO...

...HEY, *WAIT* A MINUTE...

LATER...

HUH? WHAT...

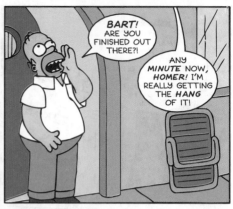

BART! ARE YOU FINISHED OUT THERE?!

ANY MINUTE NOW, HOMER! I'M REALLY GETTING THE HANG OF IT!

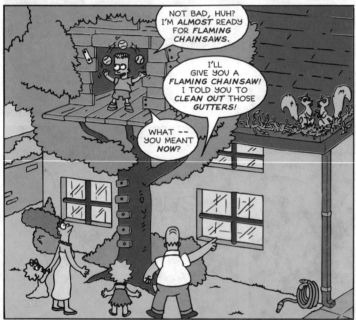

NOT BAD, HUH? I'M ALMOST READY FOR FLAMING CHAINSAWS.

I'LL GIVE YOU A FLAMING CHAINSAW! I TOLD YOU TO CLEAN OUT THOSE GUTTERS!

WHAT -- YOU MEANT NOW?

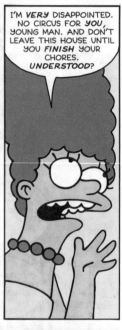

I'M VERY DISAPPOINTED. NO CIRCUS FOR YOU, YOUNG MAN. AND DON'T LEAVE THIS HOUSE UNTIL YOU FINISH YOUR CHORES. UNDERSTOOD?

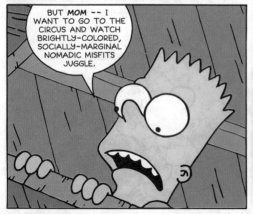

BUT MOM -- I WANT TO GO TO THE CIRCUS AND WATCH BRIGHTLY-COLORED, SOCIALLY-MARGINAL NOMADIC MISFITS JUGGLE.

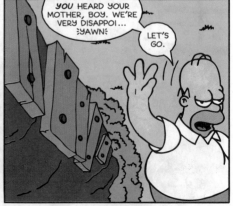

YOU HEARD YOUR MOTHER, BOY. WE'RE VERY DISAPPOI... ≥YAWN≥

LET'S GO.

40

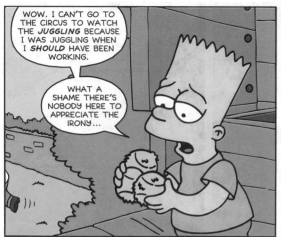

WOW. I CAN'T GO TO THE CIRCUS TO WATCH THE *JUGGLING* BECAUSE I WAS JUGGLING WHEN I *SHOULD* HAVE BEEN WORKING.

WHAT A SHAME THERE'S NOBODY HERE TO APPRECIATE THE IRONY...

HAW HAW!

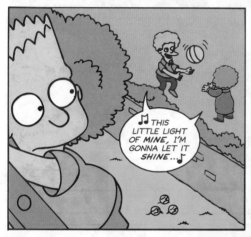

♪ THIS LITTLE LIGHT OF *MINE*, I'M GONNA LET IT *SHINE*... ♪

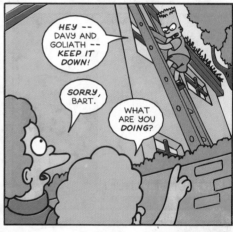

HEY -- DAVY AND GOLIATH -- *KEEP IT DOWN!*

SORRY, BART.

WHAT ARE YOU *DOING?*

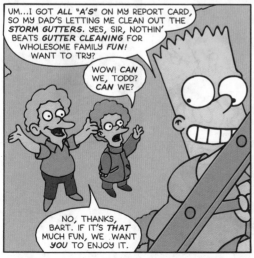

UM...I GOT *ALL "A'S"* ON MY REPORT CARD, SO MY DAD'S LETTING ME CLEAN OUT THE *STORM GUTTERS.* YES, SIR, NOTHIN' BEATS *GUTTER CLEANING* FOR WHOLESOME FAMILY *FUN!* WANT TO TRY?

WOW! *CAN* WE, TODD? *CAN* WE?

NO, THANKS, BART. IF IT'S *THAT* MUCH FUN, WE WANT *YOU* TO ENJOY IT.

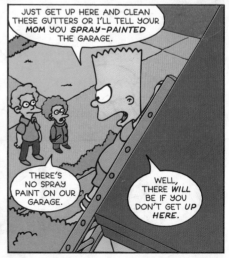

JUST GET UP HERE AND CLEAN THESE GUTTERS OR I'LL TELL YOUR *MOM* YOU *SPRAY-PAINTED* THE GARAGE.

THERE'S NO SPRAY PAINT ON OUR GARAGE.

WELL, THERE *WILL* BE IF YOU DON'T GET *UP* HERE.

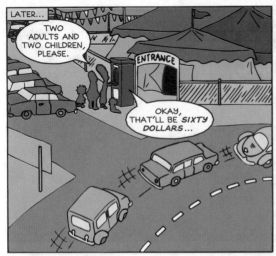

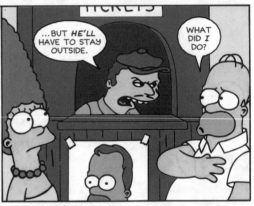

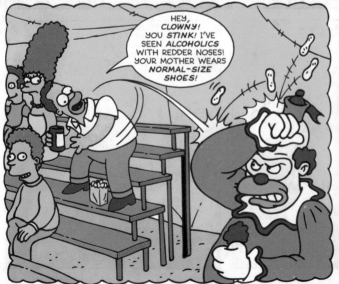

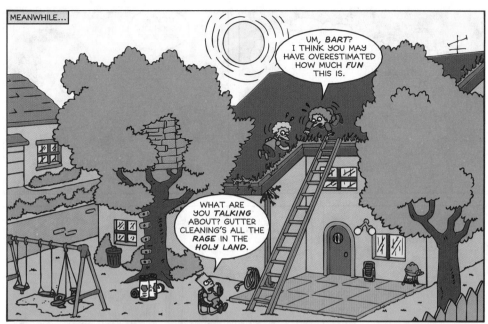

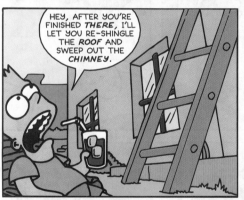

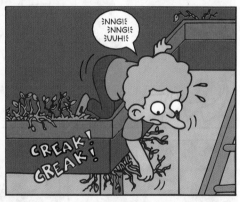

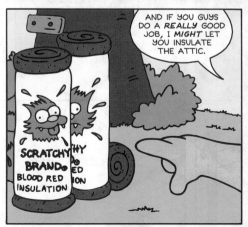

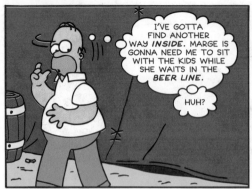

I'VE GOTTA FIND ANOTHER WAY *INSIDE*. MARGE IS GONNA NEED ME TO SIT WITH THE KIDS WHILE SHE WAITS IN THE *BEER LINE*.

HUH?

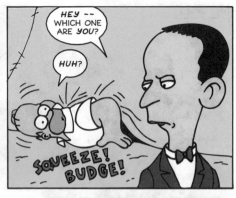

HEY -- WHICH ONE ARE *YOU*?

HUH?

SQUEEZE! BUDGE!

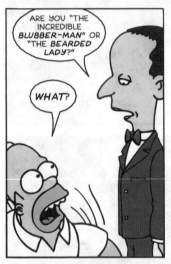

ARE YOU "THE INCREDIBLE *BLUBBER-MAN*" OR "THE *BEARDED LADY*?"

WHAT?

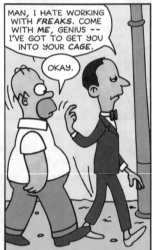

MAN, I HATE WORKING WITH *FREAKS*. COME WITH *ME*, GENIUS -- I'VE GOT TO GET YOU INTO YOUR *CAGE*.

OKAY.

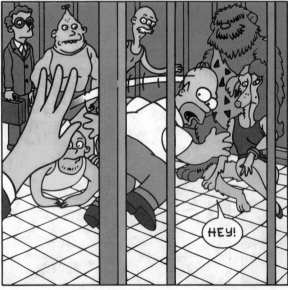

HEY!

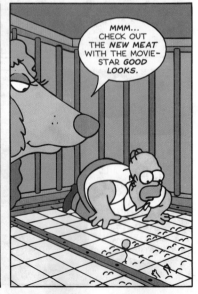

MMM... CHECK OUT THE *NEW MEAT* WITH THE MOVIE-STAR *GOOD LOOKS*.

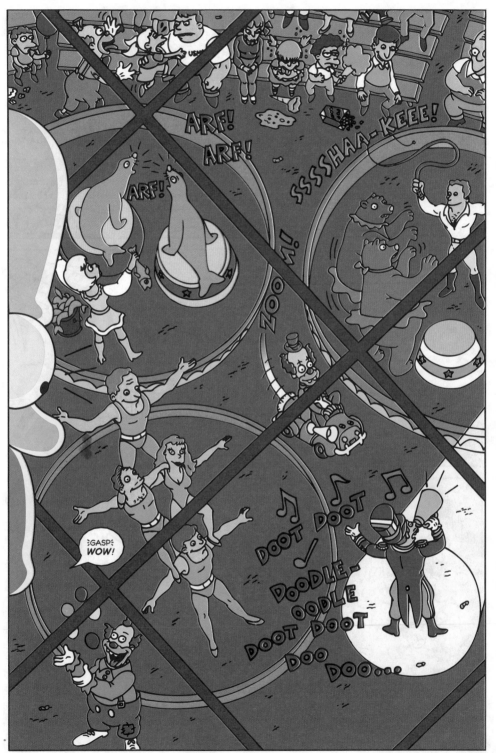

45

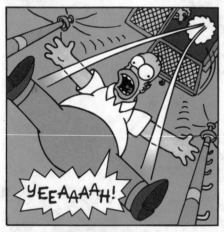

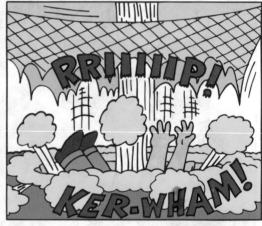

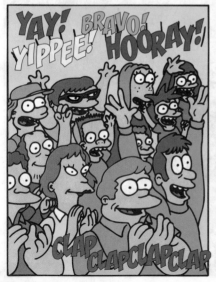

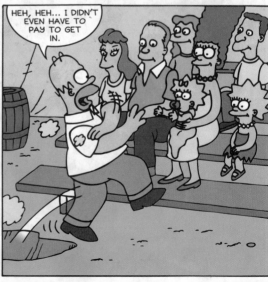

46

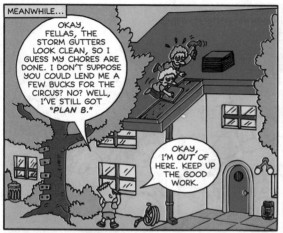

MEANWHILE...

OKAY, FELLAS, THE STORM GUTTERS LOOK CLEAN, SO I GUESS MY CHORES ARE DONE. I DON'T SUPPOSE YOU COULD LEND ME A FEW BUCKS FOR THE CIRCUS? NO? WELL, I'VE STILL GOT "PLAN B."

OKAY, I'M OUT OF HERE. KEEP UP THE GOOD WORK.

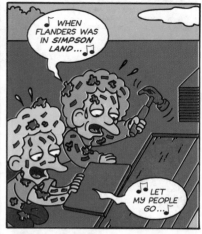

♪ WHEN FLANDERS WAS IN SIMPSON LAND... ♪

♪ LET MY PEOPLE GO... ♪

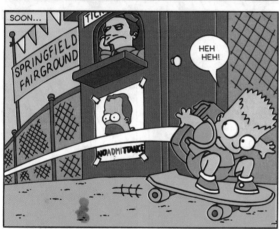

SOON...

SPRINGFIELD FAIRGROUND

NO ADMITTANCE

HEH HEH!

PORT -O- JOHN

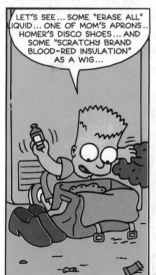

LET'S SEE... SOME "ERASE ALL" LIQUID... ONE OF MOM'S APRONS... HOMER'S DISCO SHOES... AND SOME "SCRATCHY BRAND BLOOD-RED INSULATION" AS A WIG...

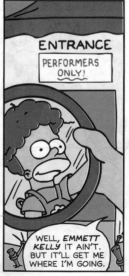

ENTRANCE

PERFORMERS ONLY!

WELL, EMMETT KELLY IT AIN'T. BUT IT'LL GET ME WHERE I'M GOING.

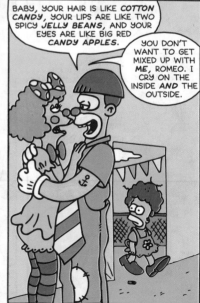

BABY, YOUR HAIR IS LIKE COTTON CANDY, YOUR LIPS ARE LIKE TWO SPICY JELLY BEANS, AND YOUR EYES ARE LIKE BIG RED CANDY APPLES.

YOU DON'T WANT TO GET MIXED UP WITH ME, ROMEO. I CRY ON THE INSIDE AND THE OUTSIDE.

47

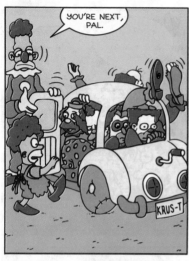

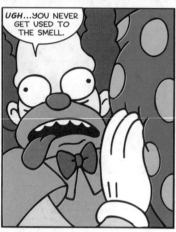

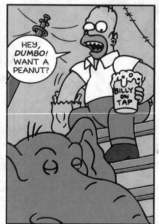

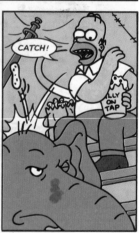

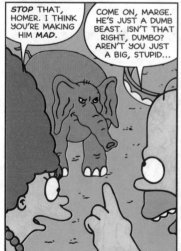

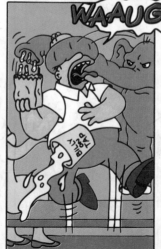

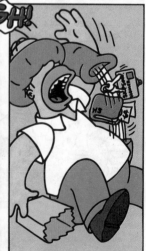

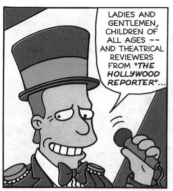

LADIES AND GENTLEMEN, CHILDREN OF ALL AGES -- AND THEATRICAL REVIEWERS FROM *THE HOLLYWOOD REPORTER*...

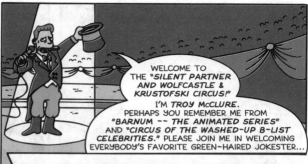

WELCOME TO THE *"SILENT PARTNER AND WOLFCASTLE & KRUSTOFSKI CIRCUS!"* I'M *TROY McCLURE.* PERHAPS YOU REMEMBER ME FROM *"BARNUM -- THE ANIMATED SERIES"* AND *"CIRCUS OF THE WASHED-UP B-LIST CELEBRITIES."* PLEASE JOIN ME IN WELCOMING EVERYBODY'S FAVORITE GREEN-HAIRED JOKESTER...

...*KRUSTY THE KLOWN* AND THOSE CRAZY CUT-UPS OF COMEDY IN THE *CLOWN CAR!*

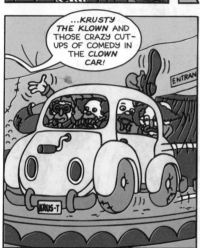

SO, I WAS UP FOR A PART IN *"SHAKES -- PART II"* -- BUT THEY GAVE IT TO SOME *OTHER* CLOWN.

YOU'VE GOTTA GET A NEW AGENT. LET ME SET YOU UP WITH *MY* GUY. *BARRY* BROKE BOZO, CLARABELLE, *AND* RONALD McDONALD.

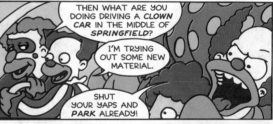

THEN WHAT ARE YOU DOING DRIVING A *CLOWN CAR* IN THE MIDDLE OF *SPRINGFIELD?*

I'M TRYING OUT SOME NEW MATERIAL.

SHUT YOUR YAPS AND *PARK* ALREADY!

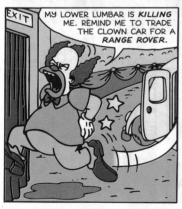

MY LOWER LUMBAR IS *KILLING* ME. REMIND ME TO TRADE THE CLOWN CAR FOR A *RANGE ROVER.*

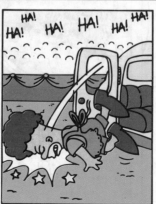

HA! HA! HA! HA! HA!

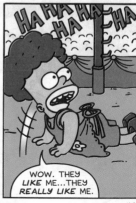

HA HA HA HA HA HA

WOW. THEY *LIKE* ME...THEY *REALLY LIKE* ME.

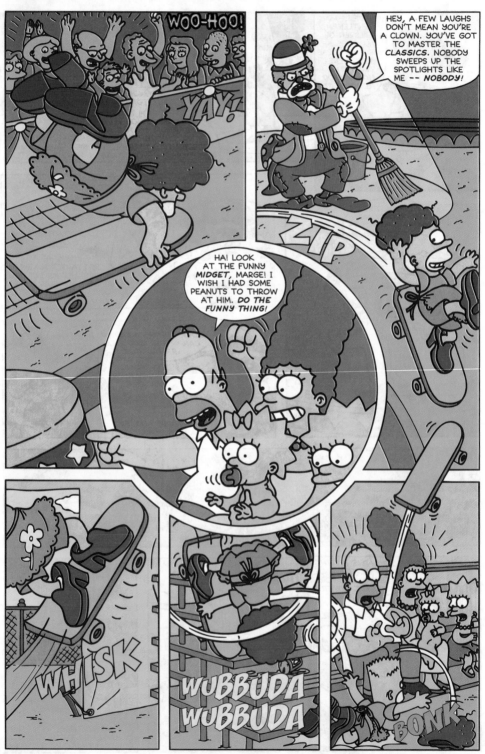

50

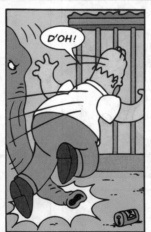

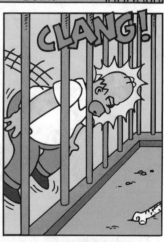

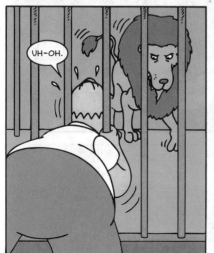

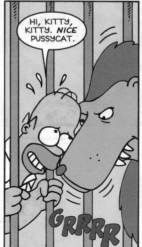

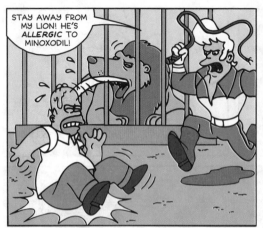

STAY AWAY FROM MY LION! HE'S *ALLERGIC* TO *MINOXODIL!*

ARE YOU *OKAY*, POOKIE? DID THE BALDING FAT MAN *FRIGHTEN* YOU?

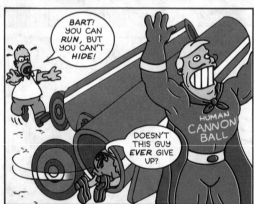

BART! YOU CAN *RUN*, BUT YOU CAN'T *HIDE!*

HUMAN CANNON BALL

DOESN'T THIS GUY *EVER* GIVE UP?

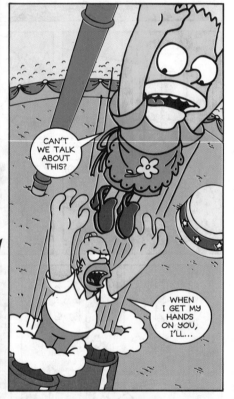

CAN'T WE TALK ABOUT THIS?

WHEN I GET MY HANDS ON YOU, I'LL...

CLANG!

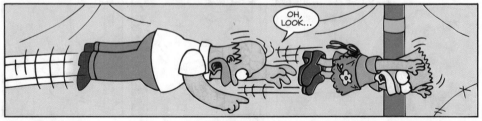

OH, LOOK...

52

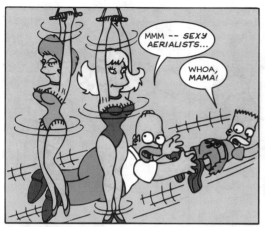
MMM -- *SEXY AERIALISTS...*

WHOA, MAMA!

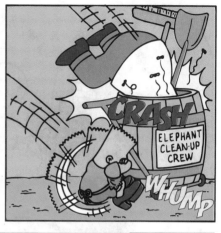
CRASH

ELEPHANT CLEAN-UP CREW

WHUMP

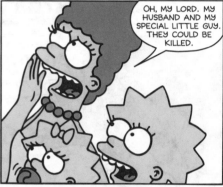
OH, MY LORD. MY HUSBAND AND MY SPECIAL LITTLE GUY. THEY COULD BE KILLED.

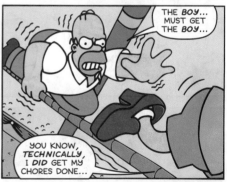
THE *BOY...* MUST GET THE *BOY...*

YOU KNOW, *TECHNICALLY,* I *DID* GET MY CHORES DONE...

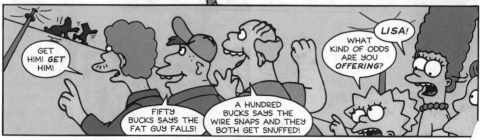
GET HIM! *GET* HIM!

FIFTY BUCKS SAYS THE FAT GUY FALLS!

A HUNDRED BUCKS SAYS THE WIRE SNAPS AND THEY BOTH GET SNUFFED!

LISA! WHAT KIND OF ODDS ARE YOU *OFFERING?*

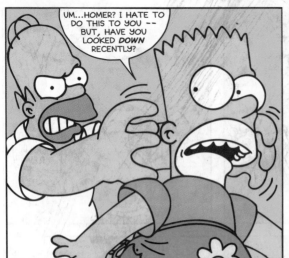

UM...HOMER? I HATE TO DO THIS TO YOU -- BUT, HAVE YOU LOOKED *DOWN* RECENTLY?

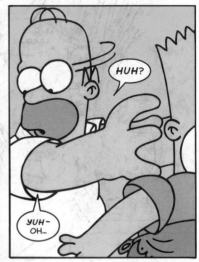

HUH?

YUH-OH...

NOT AGAIIIN!

SPLASH!

SLURP SLURP

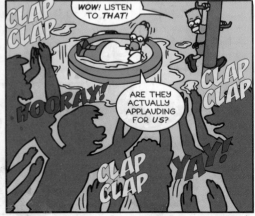

CLAP CLAP

WOW! LISTEN TO *THAT!*

HOORAY!

ARE THEY ACTUALLY APPLAUDING FOR *US?*

CLAP CLAP

CLAP CLAP

YAY!

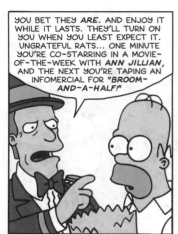

YOU BET THEY *ARE*. AND ENJOY IT WHILE IT LASTS. THEY'LL TURN ON YOU WHEN YOU LEAST EXPECT IT. UNGRATEFUL RATS... ONE MINUTE YOU'RE CO-STARRING IN A MOVIE-OF-THE-WEEK WITH *ANN JILLIAN*, AND THE NEXT YOU'RE TAPING AN INFOMERCIAL FOR *"BROOM-AND-A-HALF!"*

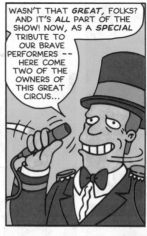

WASN'T THAT *GREAT*, FOLKS? AND IT'S *ALL* PART OF THE SHOW! NOW, AS A *SPECIAL* TRIBUTE TO OUR *BRAVE* PERFORMERS -- HERE COME TWO OF THE OWNERS OF THIS GREAT CIRCUS...

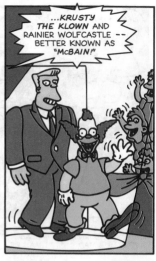

...*KRUSTY THE KLOWN* AND RAINIER WOLFCASTLE -- BETTER KNOWN AS *"McBAIN!"*

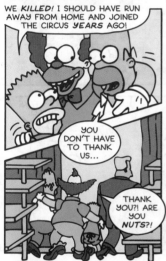

WE *KILLED*! I SHOULD HAVE RUN AWAY FROM HOME AND JOINED THE CIRCUS *YEARS* AGO!

YOU DON'T HAVE TO THANK US...

THANK YOU?! ARE YOU *NUTS*?!

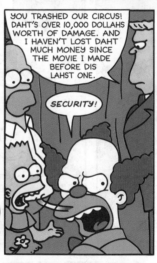

YOU TRASHED OUR CIRCUS! DAHT'S OVER 10,000 DOLLAHS WORTH OF DAMAGE. AND I HAVEN'T LOST DAHT MUCH MONEY SINCE THE MOVIE I MADE BEFORE DIS LAHST ONE.

SECURITY!

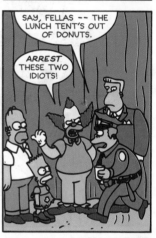

SAY, FELLAS -- THE LUNCH TENT'S OUT OF DONUTS.

ARREST THESE TWO IDIOTS!

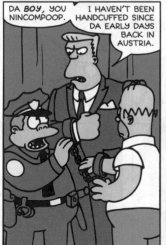

DA *BOY*, YOU NINCOMPOOP.

I HAVEN'T BEEN HANDCUFFED SINCE DA EARLY DAYS BACK IN AUSTRIA.

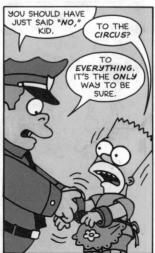

YOU SHOULD HAVE JUST SAID *"NO,"* KID.

TO THE *CIRCUS?*

TO *EVERYTHING*. IT'S THE *ONLY* WAY TO BE SURE.

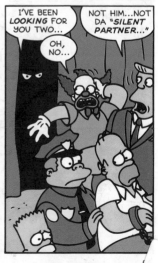

I'VE BEEN *LOOKING* FOR YOU TWO...

OH, NO...

NOT HIM...NOT DA *"SILENT PARTNER..."*

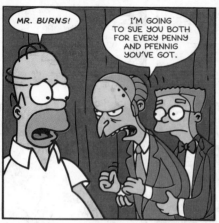

MR. BURNS!

I'M GOING TO SUE YOU BOTH FOR EVERY PENNY AND PFENNIG YOU'VE GOT.

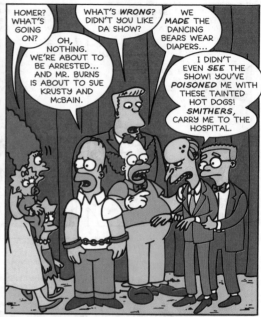

HOMER? WHAT'S GOING ON?

OH, NOTHING. WE'RE ABOUT TO BE ARRESTED... AND MR. BURNS IS ABOUT TO SUE KRUSTY AND McBAIN.

WHAT'S *WRONG*? DIDN'T YOU LIKE DA SHOW?

WE *MADE* THE DANCING BEARS WEAR DIAPERS...

I DIDN'T EVEN *SEE* THE SHOW! YOU'VE *POISONED* ME WITH THESE TAINTED HOT DOGS! *SMITHERS*, CARRY ME TO THE HOSPITAL.

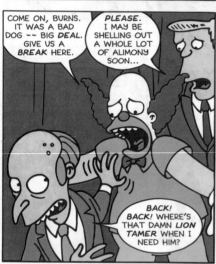

COME ON, BURNS. IT WAS A BAD DOG -- BIG *DEAL*. GIVE US A *BREAK* HERE.

PLEASE. I MAY BE SHELLING OUT A WHOLE LOT OF ALIMONY SOON...

BACK! BACK! WHERE'S THAT DAMN *LION TAMER* WHEN I NEED HIM?

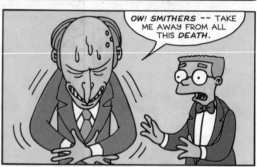

OW! SMITHERS -- TAKE ME AWAY FROM ALL THIS *DEATH*.

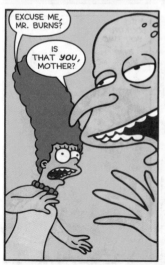

EXCUSE ME, MR. BURNS?

IS THAT *YOU*, MOTHER?

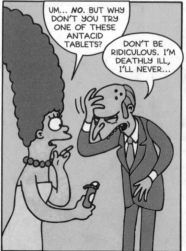

UM... *NO*. BUT WHY DON'T YOU TRY ONE OF THESE ANTACID TABLETS?

DON'T BE RIDICULOUS. I'M DEATHLY ILL, I'LL NEVER...

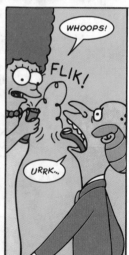

WHOOPS!

FLIK!

URRK...

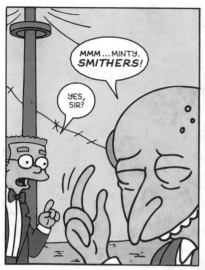

MMM...MINTY. **SMITHERS!**

YES, SIR?

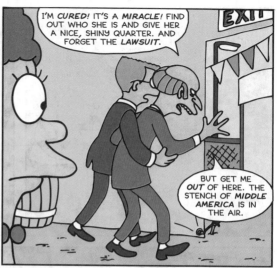

I'M *CURED!* IT'S A *MIRACLE!* FIND OUT WHO SHE IS AND GIVE HER A NICE, SHINY QUARTER. AND FORGET THE *LAWSUIT.*

BUT GET ME *OUT* OF HERE. THE STENCH OF *MIDDLE AMERICA* IS IN THE AIR.

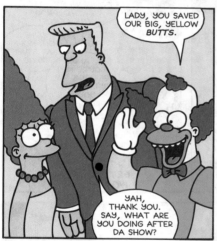

LADY, YOU SAVED OUR BIG, YELLOW *BUTTS.*

YAH, THANK YOU. SAY, WHAT ARE YOU DOING AFTER DA SHOW?

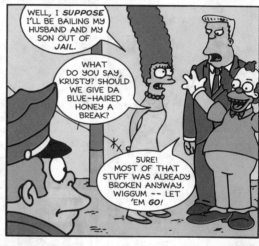

WELL, I *SUPPOSE* I'LL BE BAILING MY HUSBAND AND MY SON OUT OF *JAIL.*

WHAT DO YOU SAY, KRUSTY? SHOULD WE GIVE DA BLUE-HAIRED HONEY A BREAK?

SURE! MOST OF THAT STUFF WAS ALREADY BROKEN ANYWAY. WIGGUM -- LET 'EM *GO!*

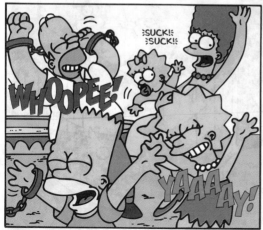

WHOOPEE!

:SUCK!: :SUCK!:

YAAAAY!

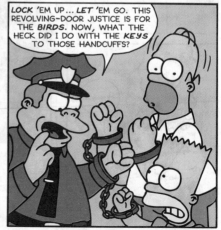

LOCK 'EM UP... *LET* 'EM GO. THIS REVOLVING-DOOR JUSTICE IS FOR THE *BIRDS.* NOW, WHAT THE HECK DID I DO WITH THE *KEYS* TO THOSE HANDCUFFS?

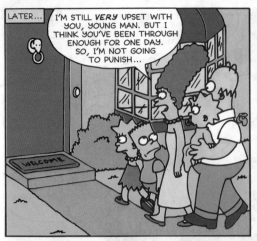

LATER... I'M STILL *VERY* UPSET WITH YOU, YOUNG MAN. BUT I THINK YOU'VE BEEN THROUGH ENOUGH FOR ONE DAY. SO, I'M NOT GOING TO PUNISH...

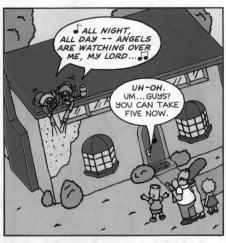

♪ ALL NIGHT, ALL DAY -- ANGELS ARE WATCHING OVER ME, MY LORD... ♪

UH-OH. UM...GUYS? YOU CAN TAKE FIVE NOW.

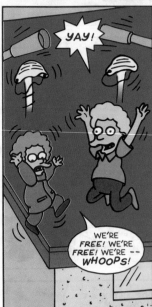

YAY!

WE'RE FREE! WE'RE FREE! WE'RE -- *WHOOPS!*

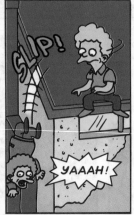

SLIP!

YAAAH!

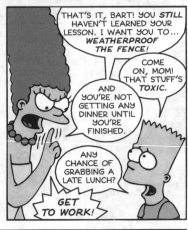

THAT'S IT, BART! YOU *STILL* HAVEN'T LEARNED YOUR LESSON. I WANT YOU TO... *WEATHERPROOF THE FENCE!*

COME ON, MOM! THAT STUFF'S *TOXIC.*

AND YOU'RE NOT GETTING ANY DINNER UNTIL YOU'RE FINISHED.

ANY CHANCE OF GRABBING A LATE LUNCH?

GET TO WORK!

Hmmm...

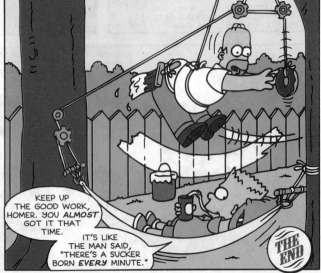

KEEP UP THE GOOD WORK, HOMER. YOU *ALMOST* GOT IT THAT TIME.

IT'S LIKE THE MAN SAID, "THERE'S A SUCKER BORN *EVERY* MINUTE."

THE END

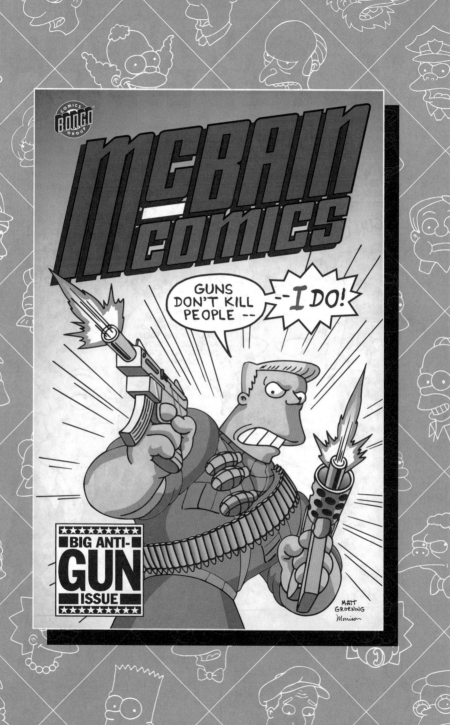

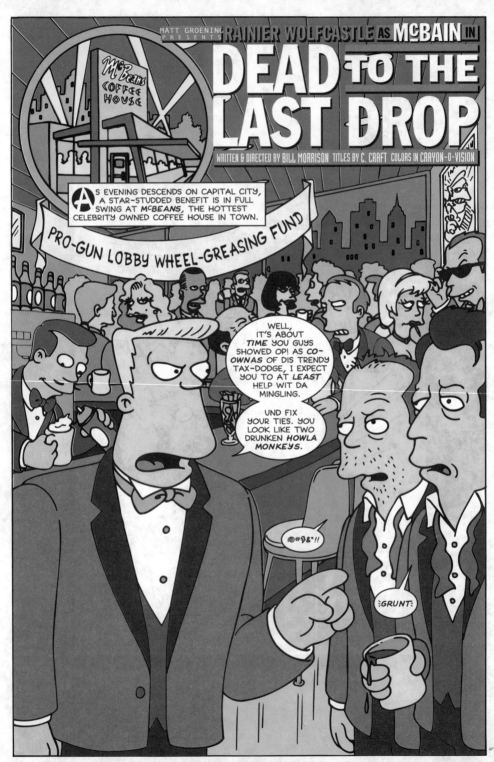

WELL, *HELLO* McBAIN... ER, I MEAN RAINIER.

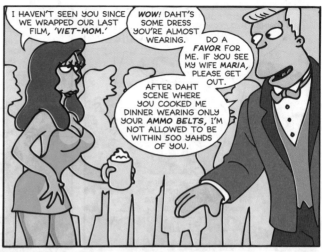

I HAVEN'T SEEN YOU SINCE WE WRAPPED OUR LAST FILM, *'VIET-MOM.'*

WOW! DAHT'S SOME DRESS YOU'RE ALMOST WEARING.

DO A *FAVOR* FOR ME. IF YOU SEE MY WIFE *MARIA*, PLEASE GET OUT.

AFTER DAHT SCENE WHERE YOU COOKED ME DINNER WEARING ONLY YOUR *AMMO BELTS*, I'M NOT ALLOWED TO BE WITHIN 500 YAHDS OF YOU.

SO TELL ME, WHAT'S THIS FUNDRAISER ALL ABOUT?

YAH, I'M NOT TOO SURE...

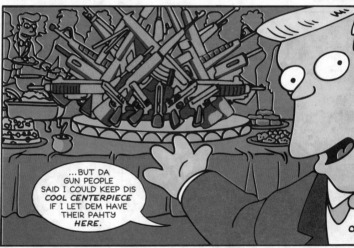

...BUT DA GUN PEOPLE SAID I COULD KEEP DIS *COOL CENTERPIECE* IF I LET DEM HAVE THEIR PAHTY *HERE*.

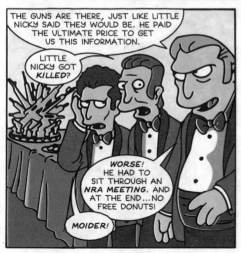

THE GUNS ARE THERE, JUST LIKE LITTLE NICKY SAID THEY WOULD BE. HE PAID THE ULTIMATE PRICE TO GET US THIS INFORMATION.

LITTLE NICKY GOT *KILLED*?

WORSE! HE HAD TO SIT THROUGH AN *NRA MEETING.* AND AT THE END...NO FREE DONUTS!

MOIDER!

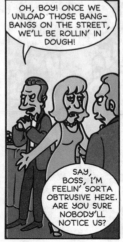

OH, BOY! ONCE WE UNLOAD THOSE BANG-BANGS ON THE STREET, WE'LL BE ROLLIN' IN DOUGH!

SAY, BOSS, I'M FEELIN' SORTA OBTRUSIVE HERE. ARE YOU SURE NOBODY'LL NOTICE US?

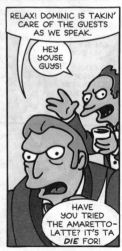

RELAX! DOMINIC IS TAKIN' CARE OF THE GUESTS AS WE SPEAK.

HEY YOUSE GUYS!

HAVE YOU TRIED THE AMARETTO-LATTE? IT'S TA *DIE* FOR!

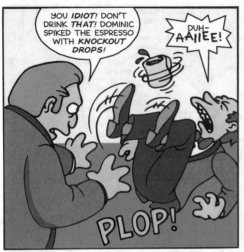

YOU *IDIOT!* DON'T DRINK *THAT!* DOMINIC SPIKED THE ESPRESSO WITH *KNOCKOUT DROPS!*

DUH— AAIIEE!

PLOP!

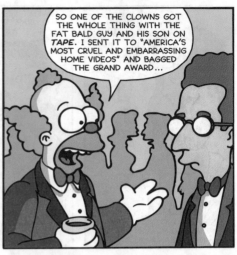

SO ONE OF THE CLOWNS GOT THE WHOLE THING WITH THE FAT BALD GUY AND HIS SON ON *TAPE.* I SENT IT TO "AMERICA'S MOST CRUEL AND EMBARRASSING HOME VIDEOS" AND BAGGED THE GRAND AWARD...

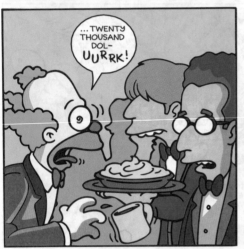

...TWENTY THOUSAND DOL— UURRK!

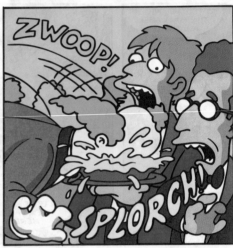

ZWOOP!

SPLORCH!

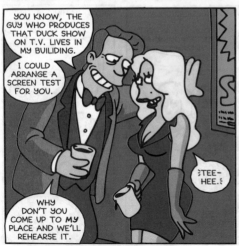

YOU KNOW, THE GUY WHO PRODUCES THAT DUCK SHOW ON T.V. LIVES IN MY BUILDING.

I COULD ARRANGE A SCREEN TEST FOR YOU.

≩TEE— HEE.≩

WHY DON'T YOU COME UP TO *MY* PLACE AND WE'LL REHEARSE IT.

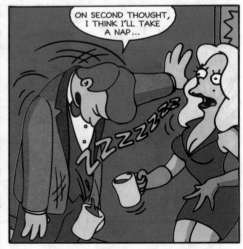

ON SECOND THOUGHT, I THINK I'LL TAKE A NAP...

ZZZZZZZ

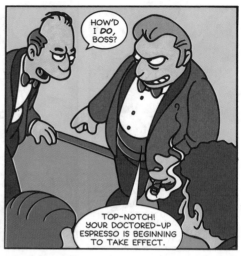

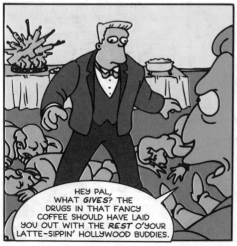

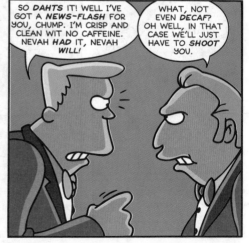

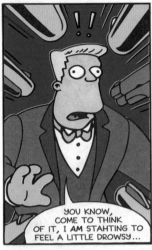

YOU KNOW, COME TO THINK OF IT, I *AM* STAHTING TO FEEL A LITTLE DROWSY...

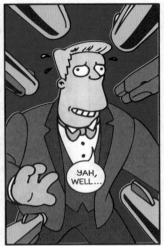

YAH, WELL...

BYE BYE, NOW!

ZIP!

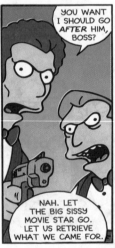

YOU WANT I SHOULD GO *AFTER* HIM, BOSS?

NAH. LET THE BIG SISSY MOVIE STAR GO. LET US RETRIEVE WHAT WE CAME FOR.

SLAM!

I'LL JUST HIDE HERE IN DA OFFICE UNTIL DEY GO AWAY.

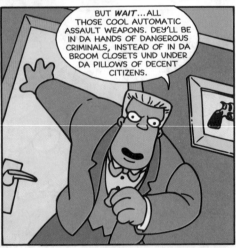

BUT *WAIT*...ALL THOSE COOL AUTOMATIC ASSAULT WEAPONS. DEY'LL BE IN DA HANDS OF DANGEROUS CRIMINALS, INSTEAD OF IN DA BROOM CLOSETS UND UNDER DA PILLOWS OF DECENT CITIZENS.

I'VE GOT TO *DO* SOME-THING, BUT *WHAT?*

I'M NOT AN ACTION HERO. I'M JUST A PERFECTLY PUMPED *FILM ACTOR*.

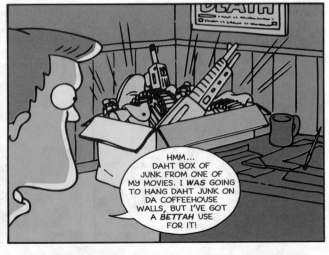

HMM... DAHT BOX OF JUNK FROM ONE OF MY MOVIES. I *WAS* GOING TO HANG DAHT JUNK ON DA COFFEEHOUSE WALLS, BUT I'VE GOT A *BETTAH* USE FOR IT!

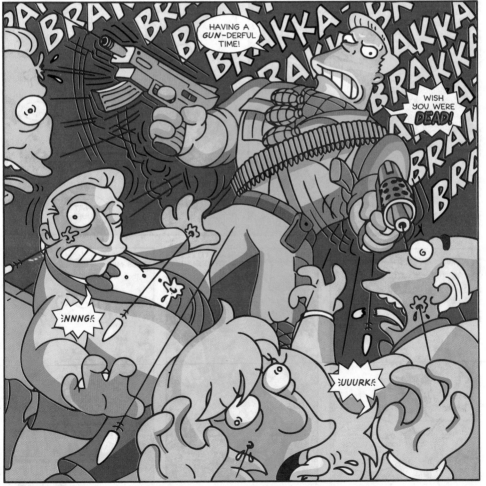

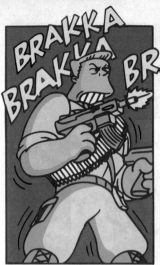

BRAKKA BRAKKA

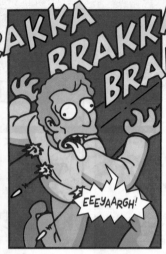

BRAKKA BRAKKA BRAKKA

EEEYAARGH!

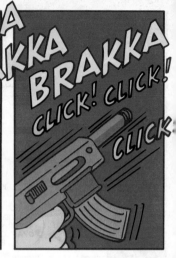

BRAKKA BRAKKA

CLICK! CLICK! CLICK!

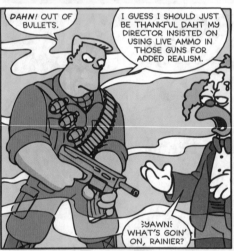

DAHN! OUT OF BULLETS.

I GUESS I SHOULD JUST BE THANKFUL DAHT MY DIRECTOR INSISTED ON USING LIVE AMMO IN THOSE GUNS FOR ADDED REALISM.

≡YAWN≡ WHAT'S GOIN' ON, RAINIER?

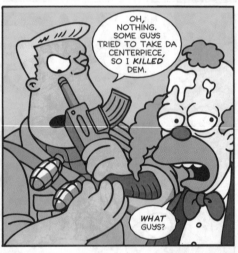

OH, NOTHING. SOME GUYS TRIED TO TAKE DA CENTERPIECE, SO I *KILLED* DEM.

WHAT GUYS?

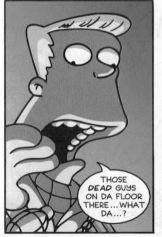

THOSE *DEAD* GUYS ON DA FLOOR THERE... WHAT DA...?

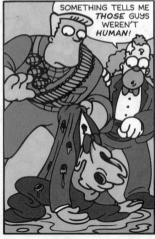

SOMETHING TELLS ME *THOSE* GUYS WEREN'T *HUMAN!*

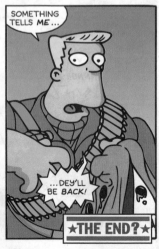

SOMETHING TELLS *ME*...

...DEY'LL BE *BACK!*

★THE END?★

66

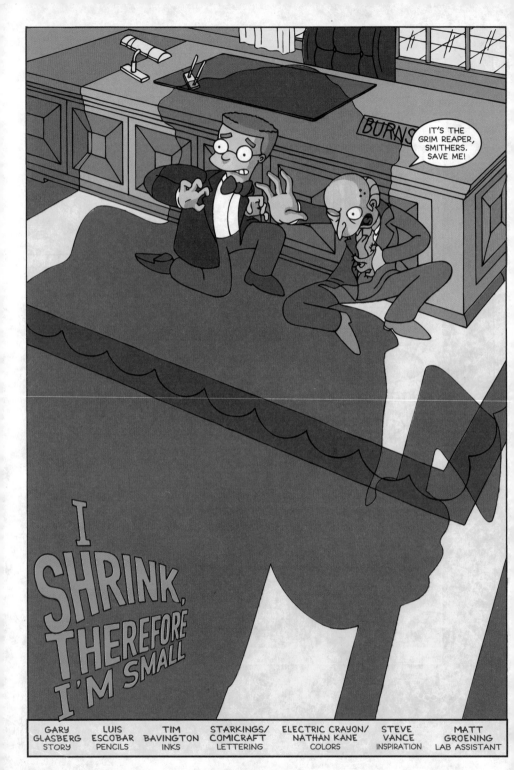

DID SOMEONE BEEP ME? I WAS IN A MEETING.

DOCTOR! IT'S AN EMERGENCY!

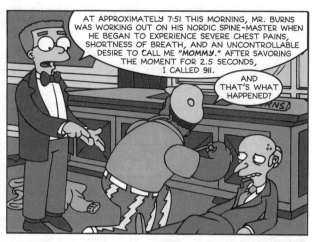

AT APPROXIMATELY 7:51 THIS MORNING, MR. BURNS WAS WORKING OUT ON HIS NORDIC SPINE-MASTER WHEN HE BEGAN TO EXPERIENCE SEVERE CHEST PAINS, SHORTNESS OF BREATH, AND AN UNCONTROLLABLE DESIRE TO CALL ME "MOMMY." AFTER SAVORING THE MOMENT FOR 2.5 SECONDS, I CALLED 911.

AND THAT'S WHAT HAPPENED?

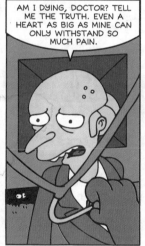

AM I DYING, DOCTOR? TELL ME THE TRUTH. EVEN A HEART AS BIG AS MINE CAN ONLY WITHSTAND SO MUCH PAIN.

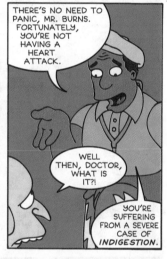

THERE'S NO NEED TO PANIC, MR. BURNS. FORTUNATELY, YOU'RE NOT HAVING A HEART ATTACK.

WELL THEN, DOCTOR, WHAT IS IT?!

YOU'RE SUFFERING FROM A SEVERE CASE OF INDIGESTION.

BUT THAT'S IMPOSSIBLE! I MONITOR MR. BURNS' DIET PERSONALLY.

HMMM... THIS DOESN'T SURPRISE ME. THERE'S SOMETHING YOU BOTH SHOULD KNOW. MY MALADY BEGAN BACK IN 1929...

I WAS JUST AN IDEALISTIC YOUNG CAPITALIST WORKING FOR MY FATHER'S BROKERAGE FIRM IN NEW YORK. IT WAS A DAY I SHALL NEVER FORGET...

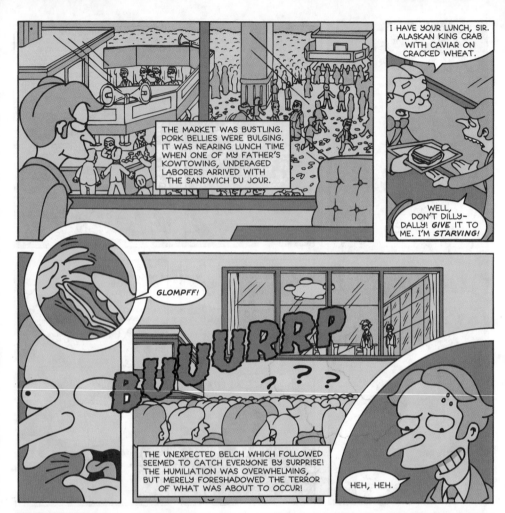

I HAVE YOUR LUNCH, SIR. ALASKAN KING CRAB WITH CAVIAR ON CRACKED WHEAT.

THE MARKET WAS BUSTLING. PORK BELLIES WERE BULGING. IT WAS NEARING LUNCH TIME WHEN ONE OF MY FATHER'S KOWTOWING, UNDERAGED LABORERS ARRIVED WITH THE SANDWICH DU JOUR.

WELL, DON'T DILLY-DALLY! *GIVE* IT TO ME. I'M *STARVING!*

GLOMPFF!

BUUURRP

? ? ?

THE UNEXPECTED BELCH WHICH FOLLOWED SEEMED TO CATCH EVERYONE BY SURPRISE! THE HUMILIATION WAS OVERWHELMING, BUT MERELY FORESHADOWED THE TERROR OF WHAT WAS ABOUT TO OCCUR!

HEH, HEH.

RRIIIIINNNG

THE MARKET BEGAN TO PLUMMET LIKE A LED ZEPPELIN. CORPORATIONS WERE COLLAPSING BEFORE MY VERY EYES!

THE DESPERATION OF MY CO-WORKERS WAS HORRIFYING. I WAS WITNESSING THE DEMISE OF AMERICAN BUSINESS!

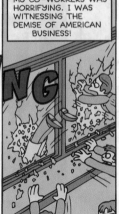

AND, SOMEHOW, IT ALL SEEMED TO BE *MY* FAULT. MY UNTIMELY ERUCTATION SEEMED TO BE RESPONSIBLE FOR THE BEGINNING OF OUR COUNTRY'S GREAT DEPRESSION!

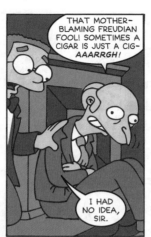

FROM THAT POINT ON, I HAVE SUBCONSCIOUSLY SUPPRESSED MY NEED TO PEPTICALLY VENT.

AT LEAST THAT'S WHAT MY OVERPAID ANALYST TELLS ME.

THAT MOTHER-BLAMING FREUDIAN FOOL! SOMETIMES A CIGAR IS JUST A CIG-AAARRGH!

I HAD NO IDEA, SIR.

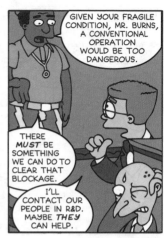

GIVEN YOUR FRAGILE CONDITION, MR. BURNS, A CONVENTIONAL OPERATION WOULD BE TOO DANGEROUS.

THERE *MUST* BE SOMETHING WE CAN DO TO CLEAR THAT BLOCKAGE.

I'LL CONTACT OUR PEOPLE IN R&D. MAYBE *THEY* CAN HELP.

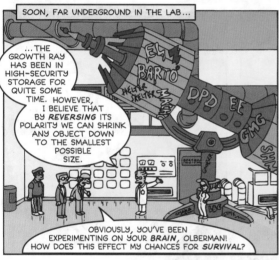

SOON, FAR UNDERGROUND IN THE LAB...

...THE GROWTH RAY HAS BEEN IN HIGH-SECURITY STORAGE FOR QUITE SOME TIME. HOWEVER, I BELIEVE THAT BY *REVERSING* ITS POLARITY WE CAN SHRINK ANY OBJECT DOWN TO THE SMALLEST POSSIBLE SIZE.

OBVIOUSLY, YOU'VE BEEN EXPERIMENTING ON YOUR *BRAIN*, OLBERMAN! HOW DOES THIS EFFECT MY CHANCES FOR *SURVIVAL*?

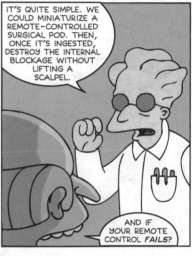

IT'S QUITE SIMPLE. WE COULD MINIATURIZE A REMOTE-CONTROLLED SURGICAL POD. THEN, ONCE IT'S INGESTED, DESTROY THE INTERNAL BLOCKAGE WITHOUT LIFTING A SCALPEL.

AND IF YOUR REMOTE CONTROL *FAILS*?

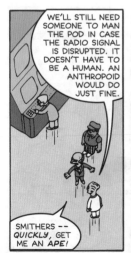

WE'LL STILL NEED SOMEONE TO MAN THE POD IN CASE THE RADIO SIGNAL IS DISRUPTED. IT DOESN'T HAVE TO BE A HUMAN. AN ANTHROPOID WOULD DO JUST FINE.

SMITHERS -- *QUICKLY*, GET ME AN *APE*!

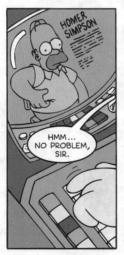

HOMER SIMPSON

HMM... NO PROBLEM, SIR.

FLOOP

UURRRK!

PREPARE THE RAY, DOCTOR! AND HURRY!

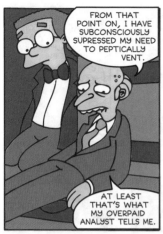

71

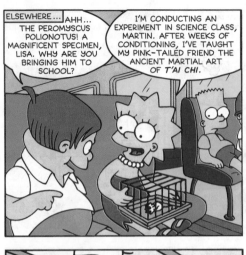

ELSEWHERE... AHH... THE PEROMYSCUS POLIONOTUS! A MAGNIFICENT SPECIMEN, LISA. WHY ARE YOU BRINGING HIM TO SCHOOL?

I'M CONDUCTING AN EXPERIMENT IN SCIENCE CLASS, MARTIN. AFTER WEEKS OF CONDITIONING, I'VE TAUGHT MY PINK-TAILED FRIEND THE ANCIENT MARTIAL ART OF T'AI CHI.

HAH!

ARE YOU KIDDING? THAT DUMB MOUSE IS ONLY GOOD FOR ONE THING... SCARING GIRLS. C'MON, MILHOUSE, LET'S HAVE SOME FUN.

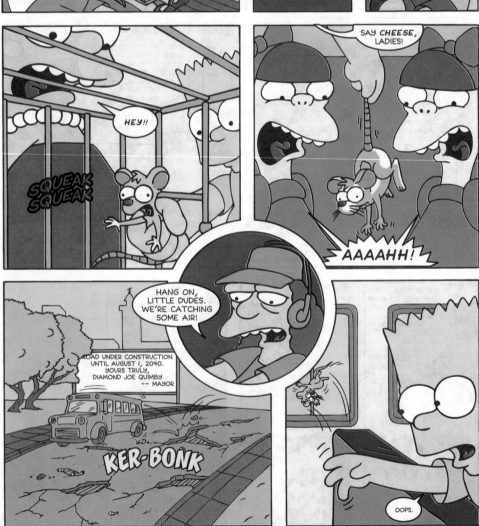

HEY!!

SQUEAK SQUEAK

SAY CHEESE, LADIES!

AAAAHH!

HANG ON, LITTLE DUDES. WE'RE CATCHING SOME AIR!

ROAD UNDER CONSTRUCTION UNTIL AUGUST 1, 2040.
YOURS TRULY,
DIAMOND JOE QUIMBY
-- MAYOR

KER-BONK

OOPS.

72

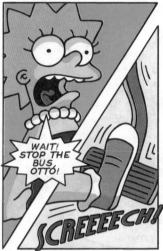

WAIT! STOP THE BUS OTTO!

SCREEEECH!

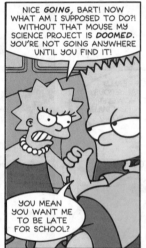

NICE *GOING,* BART! NOW WHAT AM I SUPPOSED TO DO?! WITHOUT THAT MOUSE MY SCIENCE PROJECT IS *DOOMED.* YOU'RE NOT GOING ANYWHERE UNTIL YOU FIND IT!

YOU MEAN YOU WANT ME TO BE LATE FOR SCHOOL?

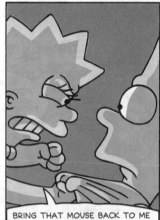

BRING THAT MOUSE BACK TO ME UNHARMED, DEAR BROTHER, OR PREPARE TO FACE THE WHITE KNUCKLED CONSEQUENCES.

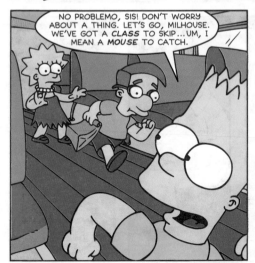

NO PROBLEMO, SIS! DON'T WORRY ABOUT A THING. LET'S GO, MILHOUSE. WE'VE GOT A *CLASS* TO SKIP...UM, I MEAN A *MOUSE* TO CATCH.

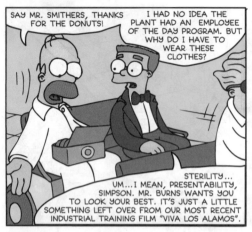

SAY MR. SMITHERS, THANKS FOR THE DONUTS!

I HAD NO IDEA THE PLANT HAD AN EMPLOYEE OF THE DAY PROGRAM. BUT WHY DO I HAVE TO WEAR THESE CLOTHES?

STERILITY... UM...I MEAN, PRESENTABILITY, SIMPSON. MR. BURNS WANTS YOU TO LOOK YOUR BEST. IT'S JUST A LITTLE SOMETHING LEFT OVER FROM OUR MOST RECENT INDUSTRIAL TRAINING FILM "VIVA LOS ALAMOS".

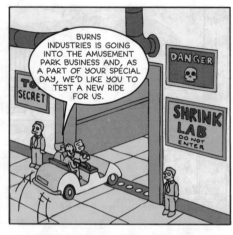

BURNS INDUSTRIES IS GOING INTO THE AMUSEMENT PARK BUSINESS AND, AS A PART OF YOUR SPECIAL DAY, WE'D LIKE YOU TO TEST A NEW RIDE FOR US.

DANGER

TOP SECRET

SHRINK LAB
DO NOT ENTER

DECONTAMINATION

THERE'S REALLY NOTHING DANGEROUS ABOUT IT. HOWEVER, THERE ARE A FEW RULES WE INSIST YOU FOLLOW.

THE DURATION OF THE VOYAGE – ER, RIDE, IS PRECISELY ONE HOUR. PLANT YOURSELF IN THE SEAT AND DON'T MOVE! AND WHATEVER YOU DO, DON'T TOUCH ANYTHING!

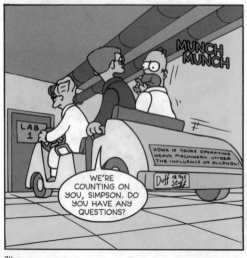

MUNCH MUNCH

LAB 1

HONK IF YOU'RE OPERATING HEAVY MACHINERY UNDER THE INFLUENCE OF ALCOHOL!

Duff IS THE SAUCE

WE'RE COUNTING ON YOU, SIMPSON. DO YOU HAVE ANY QUESTIONS?

ARE THERE ANY CHOCOLATE GLAZED OR DO THEY ALL HAVE SPRINKLES?

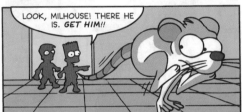

LOOK, MILHOUSE! THERE HE IS. *GET HIM!!*

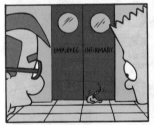

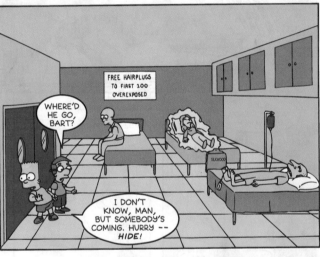

FREE HAIRPLUGS
TO FIRST 100
OVEREXPOSED

WHERE'D HE GO, BART?

I DON'T KNOW, MAN, BUT SOMEBODY'S COMING. HURRY -- *HIDE!*

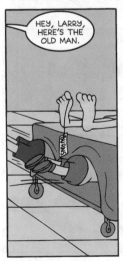

HEY, LARRY, HERE'S THE OLD MAN.

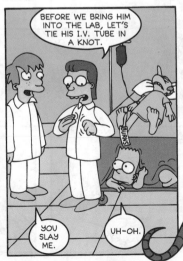

BEFORE WE BRING HIM INTO THE LAB, LET'S TIE HIS I.V. TUBE IN A KNOT.

YOU SLAY ME.

UH-OH.

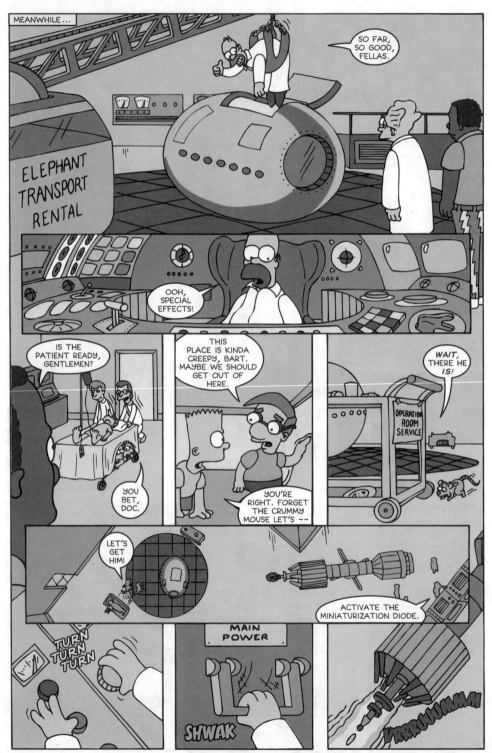

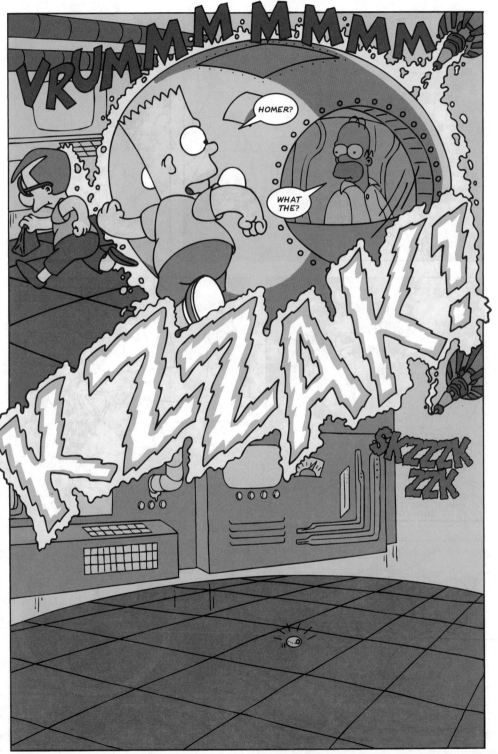

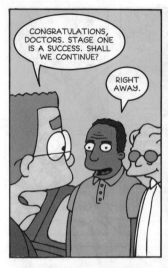

CONGRATULATIONS, DOCTORS. STAGE ONE IS A SUCCESS. SHALL WE CONTINUE?

RIGHT AWAY.

BOY, TALK ABOUT VIRTUAL REALITY! THESE CARNIVAL RIDES HAVE COME A LONG WAY SINCE I WAS A KID.

HMMM, THE *KIDNEY SHAKER* WAS MY FAVORITE.

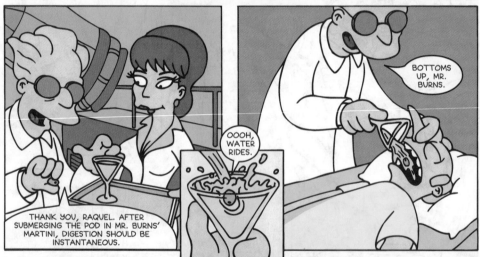

BOTTOMS UP, MR. BURNS.

OOOH, WATER RIDES.

THANK YOU, RAQUEL. AFTER SUBMERGING THE POD IN MR. BURNS' MARTINI, DIGESTION SHOULD BE INSTANTANEOUS.

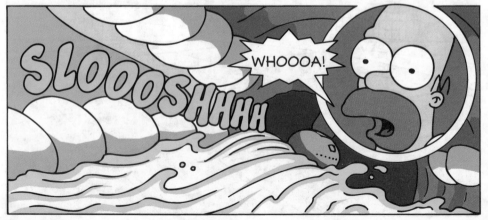

SLOOOSHHHH

WHOOOA!

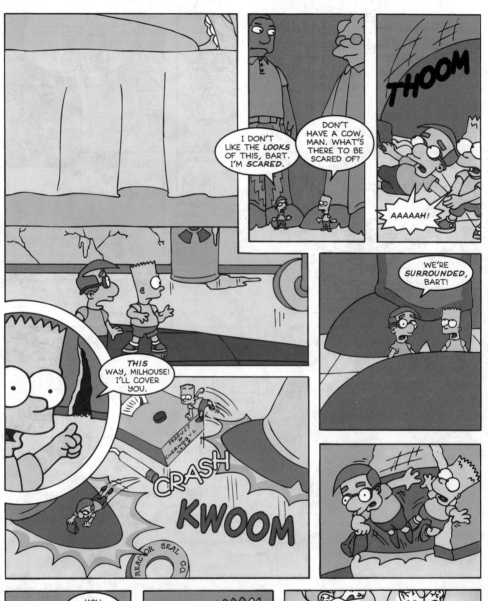

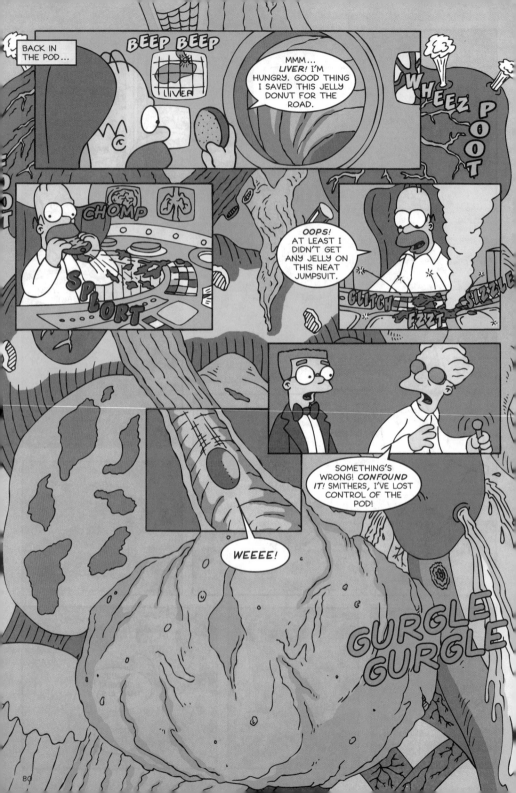

EAT COLD HARD *STEEL*, YOU *TWO-HEADED FREAK!*

GRAAH!

C'MON, BART. *THIS* WAY. *HURRY!*

WAAAHHH!

*S*PLOOSH

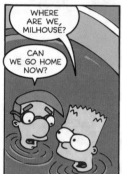

WHERE ARE WE, MILHOUSE?

CAN WE GO HOME NOW?

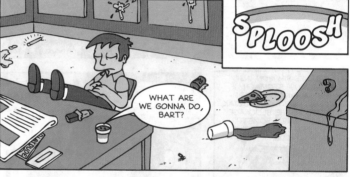

WHAT ARE WE GONNA DO, BART?

FOLLOW ME.

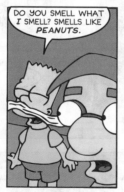

DO YOU SMELL WHAT *I* SMELL? SMELLS LIKE *PEANUTS.*

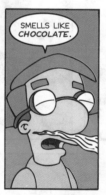

SMELLS LIKE *CHOCOLATE.*

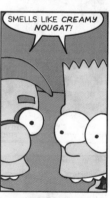

SMELLS LIKE *CREAMY NOUGAT!*

OH, *BABY!*

MUNCH MUNCH MUNCH

81

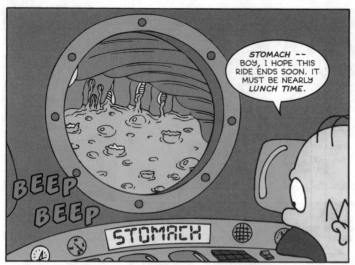

STOMACH -- BOY, I HOPE THIS RIDE ENDS SOON. IT MUST BE NEARLY *LUNCH TIME.*

BEEP BEEP

STOMACH

GENTLEMEN, COME *QUICKLY!*

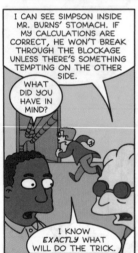

I CAN SEE SIMPSON INSIDE MR. BURNS' STOMACH. IF MY CALCULATIONS ARE CORRECT, HE WON'T BREAK THROUGH THE BLOCKAGE UNLESS THERE'S SOMETHING TEMPTING ON THE OTHER SIDE.

WHAT DID YOU HAVE IN MIND?

I KNOW *EXACTLY* WHAT WILL DO THE TRICK.

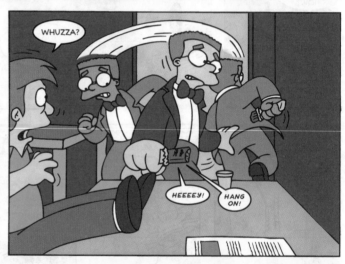

WHUZZA?

HEEEEY!

HANG ON!

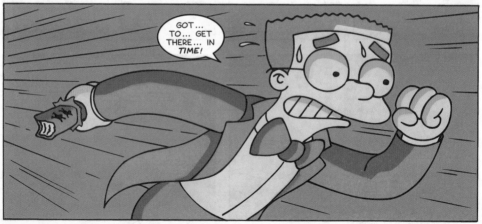

GOT... TO... GET THERE... IN *TIME!*

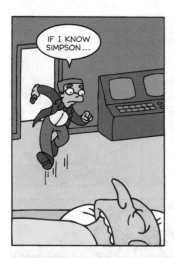

IF I KNOW SIMPSON...

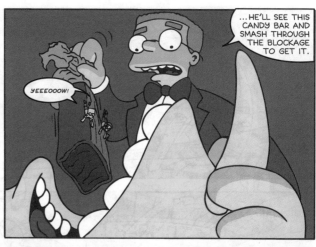

...HE'LL SEE THIS CANDY BAR AND SMASH THROUGH THE BLOCKAGE TO GET IT.

YEEEOOOW!

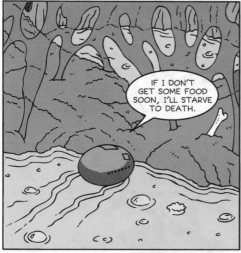

IF I DON'T GET SOME FOOD SOON, I'LL STARVE TO DEATH.

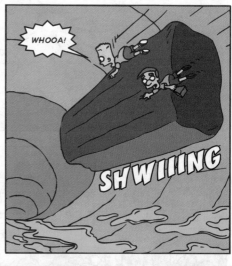

WHOOA!

SHWIIING

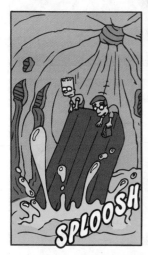

SPLOOSH

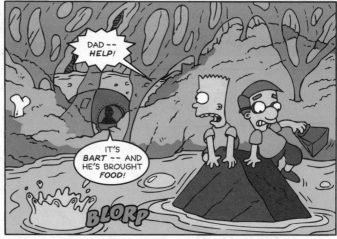

DAD -- HELP!

IT'S BART -- AND HE'S BROUGHT FOOD!

BLORP

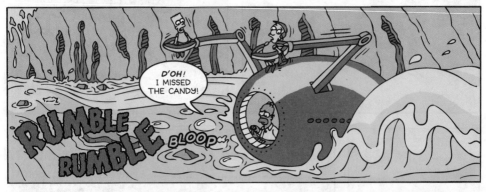

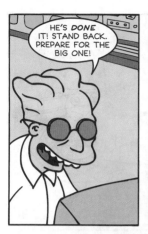

HE'S *DONE* IT! STAND BACK. PREPARE FOR THE BIG ONE!

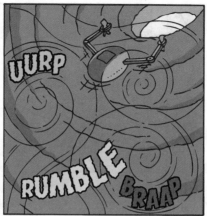

UURP

RUMBLE BRAAP

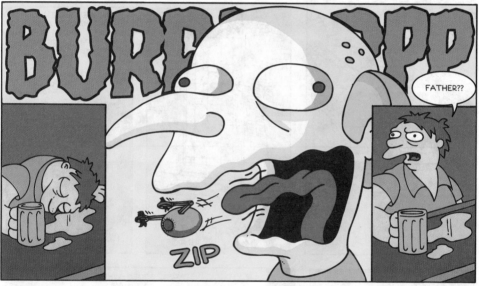

BURPPP

FATHER??

ZIP

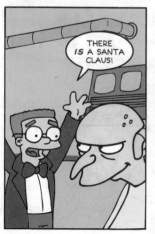

THERE *IS* A SANTA CLAUS!

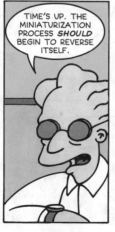

TIME'S UP. THE MINIATURIZATION PROCESS *SHOULD* BEGIN TO REVERSE ITSELF.

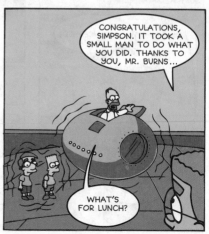

CONGRATULATIONS, SIMPSON. IT TOOK A SMALL MAN TO DO WHAT YOU DID. THANKS TO YOU, MR. BURNS...

WHAT'S FOR LUNCH?

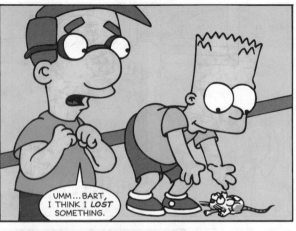

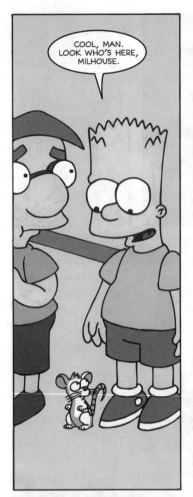

COOL, MAN. LOOK WHO'S HERE, MILHOUSE.

UMM...BART, I THINK I *LOST* SOMETHING.

AA-OO-GA!

BEEP! BEEP! BEEP!

HONK!

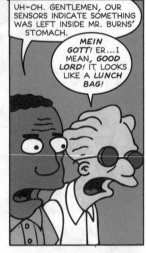

UH-OH. GENTLEMEN, OUR SENSORS INDICATE SOMETHING WAS LEFT INSIDE MR. BURNS' STOMACH.

MEIN GOTT! ER...I MEAN, *GOOD LORD!* IT LOOKS LIKE A *LUNCH BAG!*

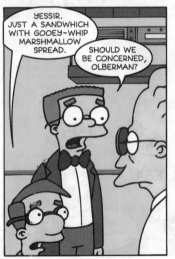

YESSIR. JUST A SANDWHICH WITH GOOEY-WHIP MARSHMALLOW SPREAD.

SHOULD WE BE CONCERNED, OLBERMAN?

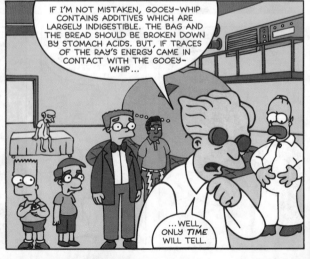

IF I'M NOT MISTAKEN, GOOEY-WHIP CONTAINS ADDITIVES WHICH ARE LARGELY INDIGESTIBLE. THE BAG AND THE BREAD SHOULD BE BROKEN DOWN BY STOMACH ACIDS. BUT, IF TRACES OF THE RAY'S ENERGY CAME IN CONTACT WITH THE GOOEY-WHIP...

...WELL, ONLY *TIME* WILL TELL.

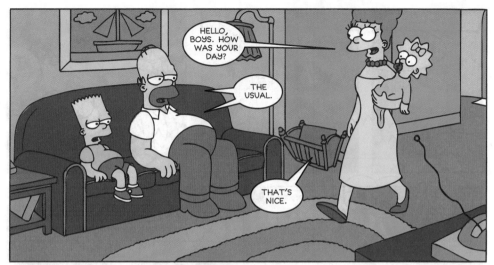

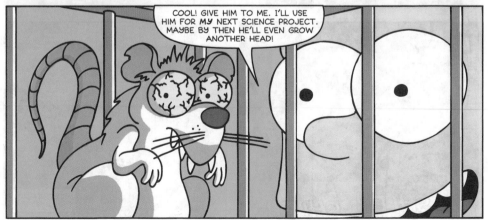

AT BURNS' MANOR...

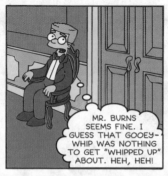

MR. BURNS SEEMS FINE. I GUESS THAT GOOEY-WHIP WAS NOTHING TO GET "WHIPPED UP" ABOUT. HEH, HEH!

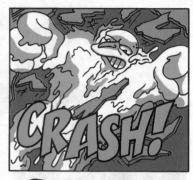

CRASH!

SLURSH

GLOMP

YAAAAH!

WHEW! FORTUNATELY, I KNOW BETTER THAN TO BELIEVE IN MONSTERS.

SKLURTCH

SHLEP SHLEP

SCRRREEE

THE END.
(WELL, MAYBE.)

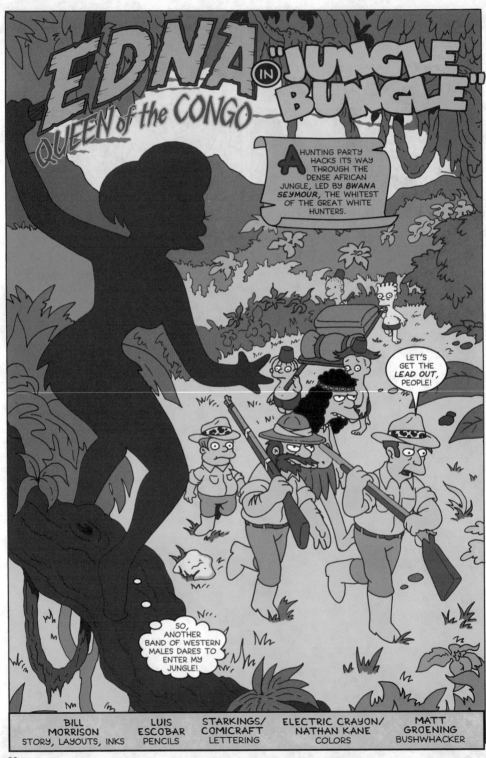

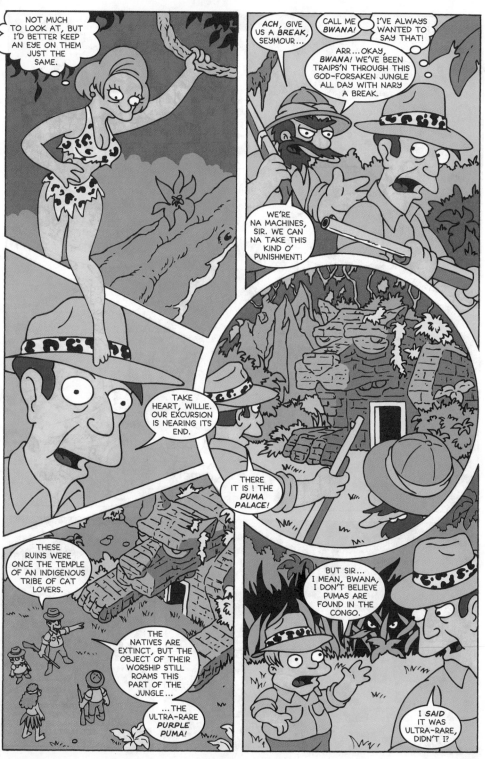

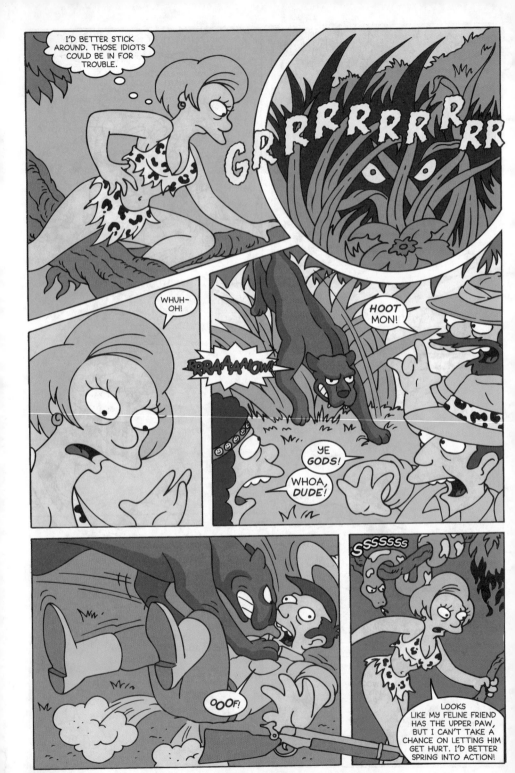

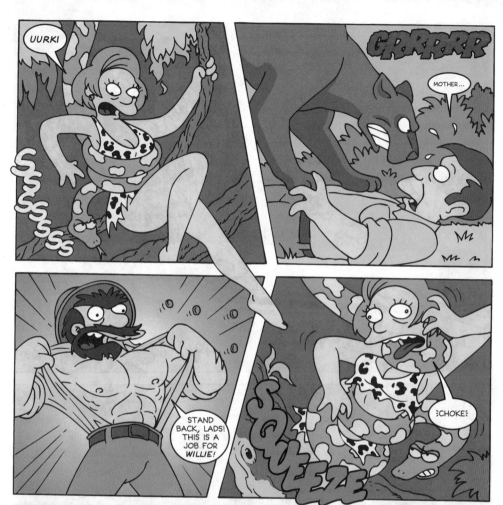

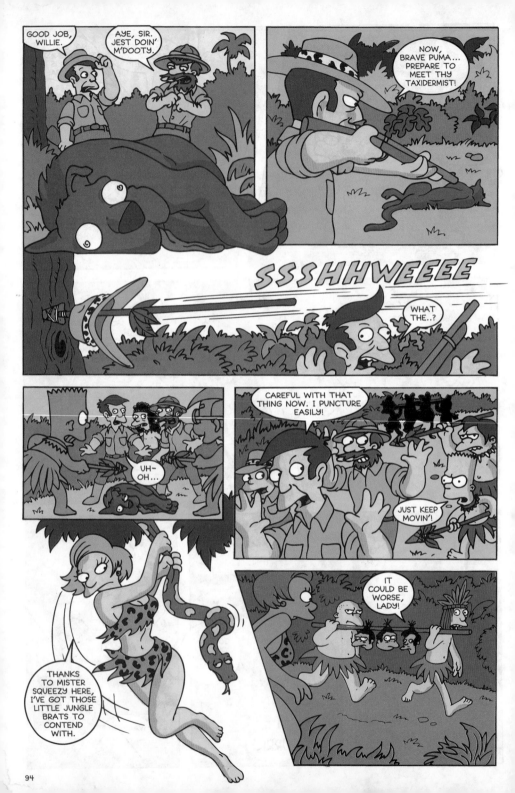

94

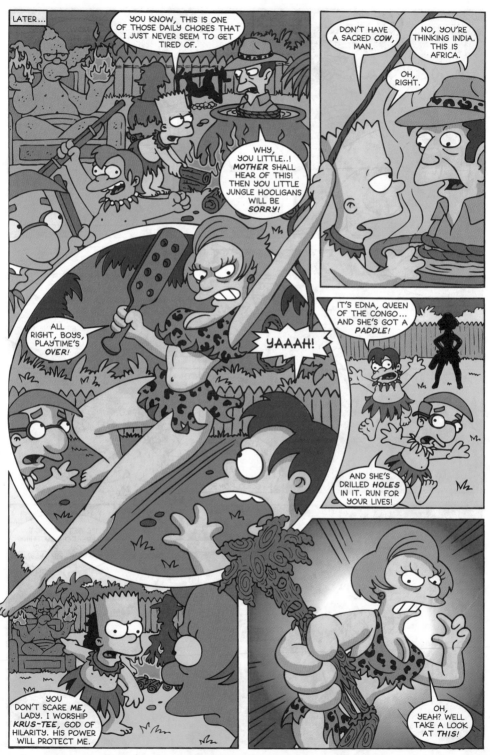

95

YEEAAH!

THAT WAS JUST TOO EASY.

DON'T KILLMEDON'T KILLMEDON'T KILLME...

THERE YOU GO, KITTY. RUN ALONG HOME NOW.

UH... WAIT! COULDN'T YOU JUST LET ME KEEP THE PUMA? I'LL GIVE HIM A GOOD HOME.

NOT ON YOUR LIFE, BUSTER. JUST ABOUT EVERY MONTH, A GROUP OF YOU IDIOT HUNTERS COMES INTO MY JUNGLE TO FIND THAT PUMA.

SO FAR, YOU'VE ALL BEEN DUDS. BUT SOMEDAY, I'M GOING TO FIND ONE OF YOU THAT'S WORTH MARRYING!

MY HERO!

MMM...

HEY, IT'S GETTING HOT IN HERE! DO YOU THINK YOU COULD PUT OUT THESE FIRES? MISS? MISS?!!

THE END

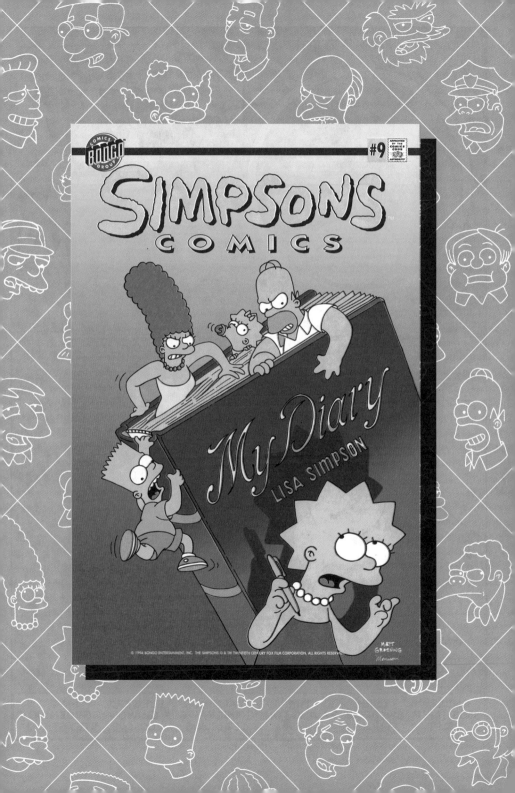

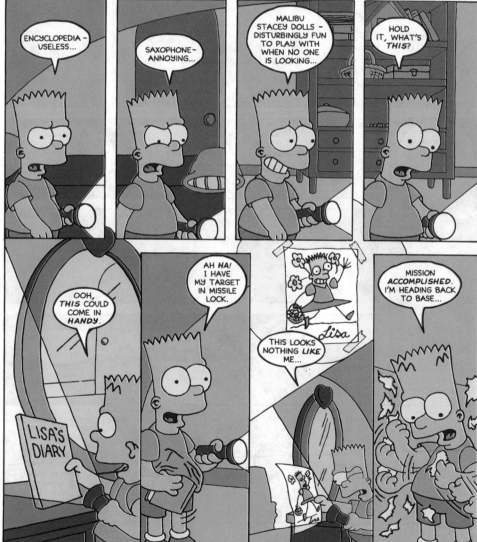

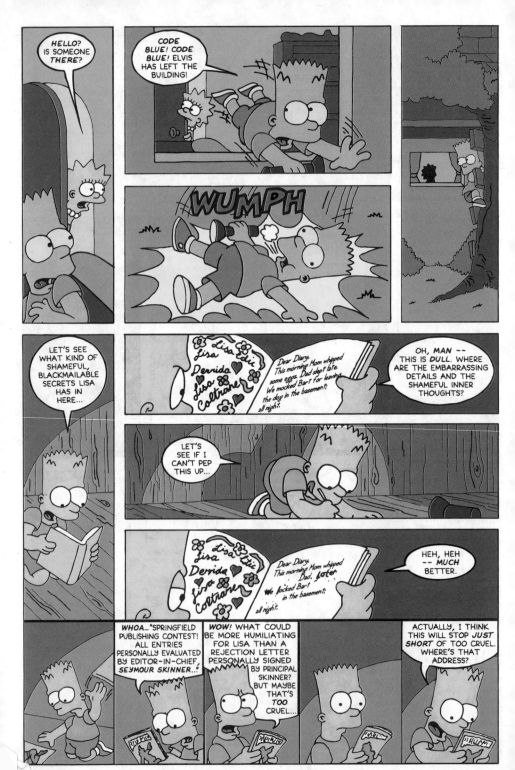

DING DONG!

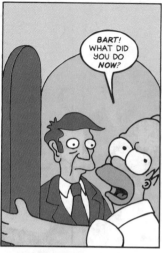

BART! WHAT DID YOU DO *NOW*?

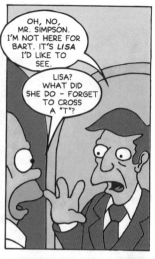

OH, NO, MR. SIMPSON. I'M NOT HERE FOR BART. IT'S *LISA* I'D LIKE TO SEE.

LISA? WHAT DID SHE DO – FORGET TO CROSS A "T"?

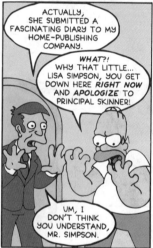

ACTUALLY, SHE SUBMITTED A FASCINATING DIARY TO MY HOME-PUBLISHING COMPANY.

WHAT?! WHY THAT LITTLE... LISA SIMPSON, YOU GET DOWN HERE *RIGHT NOW* AND *APOLOGIZE* TO PRINCIPAL SKINNER!

UM, I DON'T THINK YOU UNDERSTAND, MR. SIMPSON.

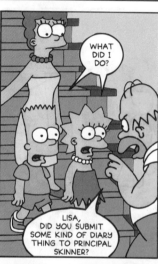

WHAT DID I DO?

LISA, DID YOU SUBMIT SOME KIND OF DIARY THING TO PRINCIPAL SKINNER?

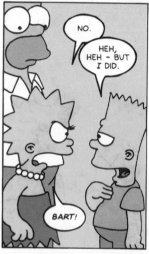

NO.

HEH, HEH – BUT *I* DID.

BART!

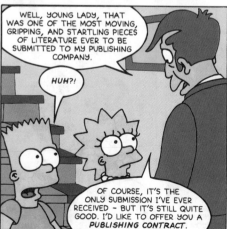

WELL, YOUNG LADY, THAT WAS ONE OF THE MOST MOVING, GRIPPING, AND STARTLING PIECES OF LITERATURE EVER TO BE SUBMITTED TO MY PUBLISHING COMPANY.

HUH?!

OF COURSE, IT'S THE ONLY SUBMISSION I'VE EVER RECEIVED – BUT IT'S STILL QUITE GOOD. I'D LIKE TO OFFER YOU A *PUBLISHING CONTRACT*.

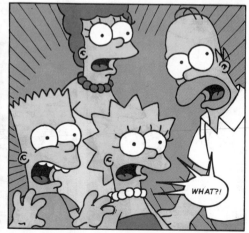

WHAT?!

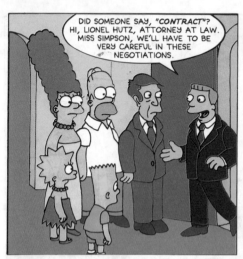

DID SOMEONE SAY, "*CONTRACT*"? HI, LIONEL HUTZ, ATTORNEY AT LAW. MISS SIMPSON, WE'LL HAVE TO BE VERY CAREFUL IN THESE NEGOTIATIONS.

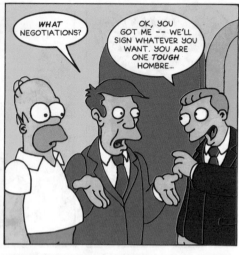

WHAT NEGOTIATIONS?

OK, YOU GOT ME -- WE'LL SIGN WHATEVER YOU WANT. YOU ARE ONE *TOUGH* HOMBRE...

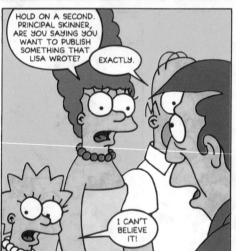

HOLD ON A SECOND. PRINCIPAL SKINNER, ARE YOU SAYING YOU WANT TO PUBLISH SOMETHING THAT LISA WROTE?

EXACTLY.

I CAN'T BELIEVE IT!

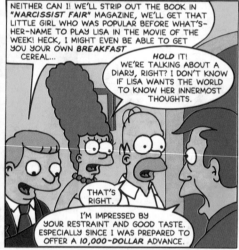

NEITHER CAN I! WE'LL STRIP OUT THE BOOK IN "*NARCISSIST FAIR*" MAGAZINE, WE'LL GET THAT LITTLE GIRL WHO WAS POPULAR BEFORE WHAT'S-HER-NAME TO PLAY LISA IN THE MOVIE OF THE WEEK! HECK, I MIGHT EVEN BE ABLE TO GET YOU YOUR OWN *BREAKFAST* CEREAL...

HOLD IT! WE'RE TALKING ABOUT A DIARY, RIGHT? I DON'T KNOW IF LISA WANTS THE WORLD TO KNOW HER INNERMOST THOUGHTS.

THAT'S RIGHT.

I'M IMPRESSED BY YOUR RESTRAINT AND GOOD TASTE. ESPECIALLY SINCE I WAS PREPARED TO OFFER A 10,000-DOLLAR ADVANCE.

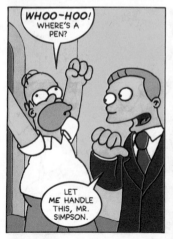

WHOO-HOO! WHERE'S A PEN?

LET *ME* HANDLE THIS, MR. SIMPSON.

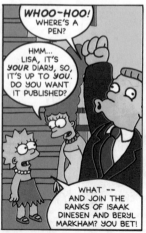

WHOO-HOO! WHERE'S A PEN?

HMM... LISA, IT'S *YOUR* DIARY, SO, IT'S UP TO *YOU*. DO YOU WANT IT PUBLISHED?

WHAT -- AND JOIN THE RANKS OF ISAAK DINESEN AND BERYL MARKHAM? YOU BET!

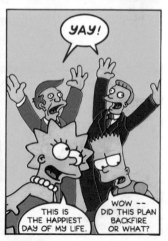

YAY!

THIS IS THE HAPPIEST DAY OF MY LIFE.

WOW -- DID THIS PLAN BACKFIRE OR WHAT?

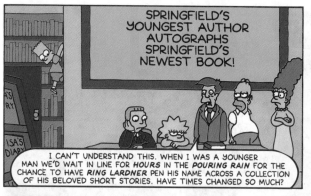

SPRINGFIELD'S YOUNGEST AUTHOR AUTOGRAPHS SPRINGFIELD'S NEWEST BOOK!

I CAN'T UNDERSTAND THIS. WHEN I WAS A YOUNGER MAN WE'D WAIT IN LINE FOR *HOURS* IN THE *POURING RAIN* FOR THE CHANCE TO HAVE *RING LARDNER* PEN HIS NAME ACROSS A COLLECTION OF HIS BELOVED SHORT STORIES. HAVE TIMES CHANGED SO MUCH?

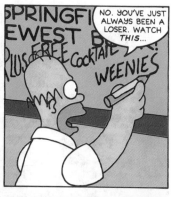

NO. YOU'VE JUST ALWAYS BEEN A LOSER. WATCH *THIS*...

WEENIES

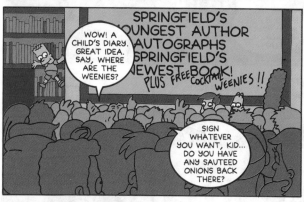

SPRINGFIELD'S YOUNGEST AUTHOR AUTOGRAPHS SPRINGFIELD'S NEWEST BOOK! PLUS FREE COCKTAIL WEENIES!!

WOW! A CHILD'S DIARY. GREAT IDEA. SAY, WHERE ARE THE WEENIES?

SIGN WHATEVER YOU WANT, KID... DO YOU HAVE ANY SAUTEED ONIONS BACK THERE?

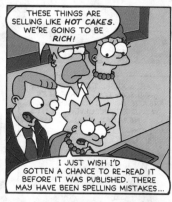

THESE THINGS ARE SELLING LIKE *HOT CAKES.* WE'RE GOING TO BE *RICH!*

I JUST WISH I'D GOTTEN A CHANCE TO RE-READ IT BEFORE IT WAS PUBLISHED. THERE MAY HAVE BEEN SPELLING MISTAKES...

WEE NIES!

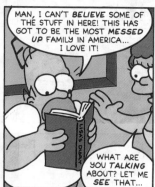

MAN, I CAN'T *BELIEVE* SOME OF THE STUFF IN HERE! THIS HAS GOT TO BE THE MOST *MESSED UP* FAMILY IN AMERICA... I LOVE IT!

WHAT ARE YOU *TALKING* ABOUT? LET ME *SEE* THAT...

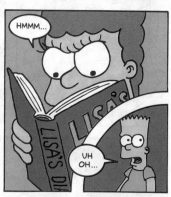

HMMM...

UH OH...

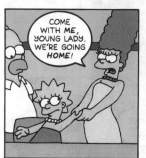

COME WITH *ME,* YOUNG LADY. WE'RE GOING *HOME!*

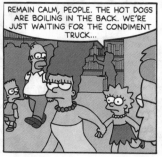

REMAIN CALM, PEOPLE. THE HOT DOGS ARE BOILING IN THE BACK. WE'RE JUST WAITING FOR THE CONDIMENT TRUCK...

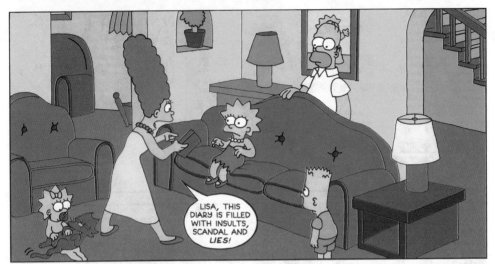

LISA, THIS DIARY IS FILLED WITH INSULTS, SCANDAL AND *LIES!*

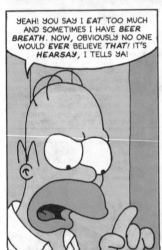

YEAH! YOU SAY I *EAT* TOO MUCH AND SOMETIMES I HAVE *BEER BREATH*. NOW, OBVIOUSLY NO ONE WOULD *EVER* BELIEVE *THAT!* IT'S *HEARSAY*, I TELLS YA!

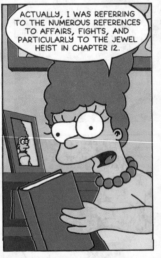

ACTUALLY, I WAS REFERRING TO THE NUMEROUS REFERENCES TO AFFAIRS, FIGHTS, AND PARTICULARLY TO THE JEWEL HEIST IN CHAPTER 12.

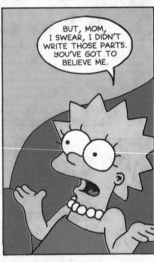

BUT, MOM, I SWEAR, I DIDN'T WRITE THOSE PARTS. YOU'VE GOT TO BELIEVE ME.

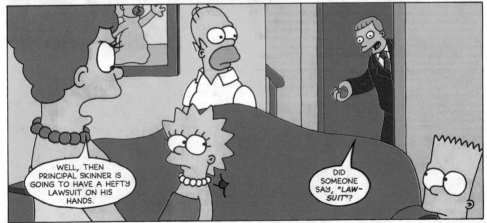

WELL, THEN PRINCIPAL SKINNER IS GOING TO HAVE A HEFTY LAWSUIT ON HIS HANDS.

DID SOMEONE SAY, "LAW-SUIT"?

OH, *BROTHER*...

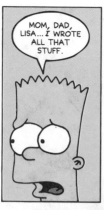

MOM, DAD, LISA... *I* WROTE ALL THAT STUFF.

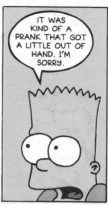

IT WAS KIND OF A PRANK THAT GOT A LITTLE OUT OF HAND. I'M SORRY.

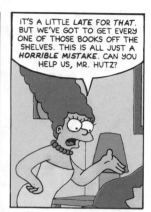

IT'S A LITTLE *LATE* FOR *THAT*. BUT WE'VE GOT TO GET EVERY ONE OF THOSE BOOKS OFF THE SHELVES. THIS IS ALL JUST A *HORRIBLE MISTAKE*. CAN YOU HELP US, MR. HUTZ?

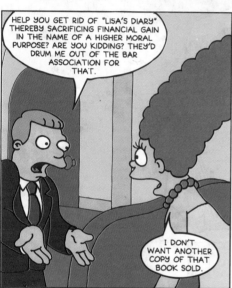

HELP YOU GET RID OF "LISA'S DIARY" THEREBY SACRIFICING FINANCIAL GAIN IN THE NAME OF A HIGHER MORAL PURPOSE? ARE YOU KIDDING? THEY'D DRUM ME OUT OF THE BAR ASSOCIATION FOR THAT.

I DON'T WANT ANOTHER COPY OF THAT BOOK SOLD.

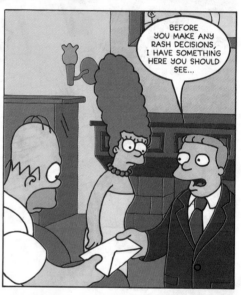

BEFORE YOU MAKE ANY RASH DECISIONS, I HAVE SOMETHING HERE YOU SHOULD SEE...

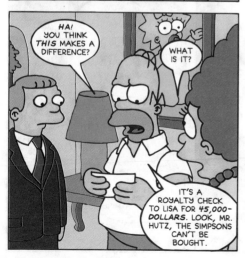

HA! YOU THINK *THIS* MAKES A DIFFERENCE?

WHAT IS IT?

IT'S A ROYALTY CHECK TO LISA FOR 45,000- DOLLARS. LOOK, MR. HUTZ, THE SIMPSONS CAN'T BE BOUGHT.

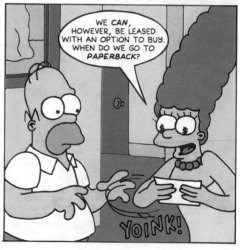

WE *CAN*, HOWEVER, BE LEASED WITH AN OPTION TO BUY. WHEN DO WE GO TO *PAPERBACK*?

YOINK!

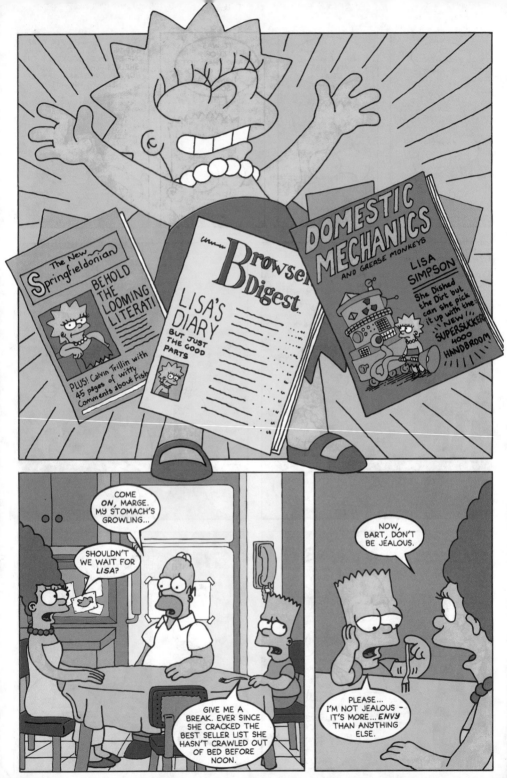

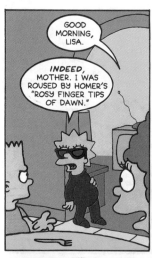

GOOD MORNING, LISA.

INDEED, MOTHER. I WAS ROUSED BY HOMER'S "ROSY FINGER TIPS OF DAWN."

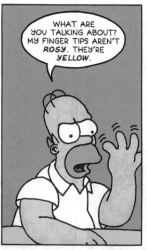

WHAT ARE YOU TALKING ABOUT? MY FINGER TIPS AREN'T ROSY. THEY'RE YELLOW.

NOT YOU, DAD. HOMER - THE GREEK AUTHOR WHO PRACTICALLY STARTED THE WESTERN LITERARY TRADITION.

OH, MAN I REFUSE TO START LEARNING STUFF AT HOME...

BEHAVE YOURSELF, BART. LISA IS JUST EXPRESSING A NEWFOUND INTEREST IN LITERATURE. I THINK IT'S WONDERFUL.

POP

THAT'S MY WAFFLE, BOY.

I SAW IT FIRST.

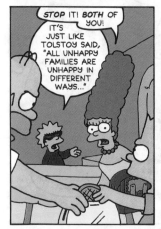

STOP IT! BOTH OF YOU!

IT'S JUST LIKE TOLSTOY SAID, "ALL UNHAPPY FAMILIES ARE UNHAPPY IN DIFFERENT WAYS..."

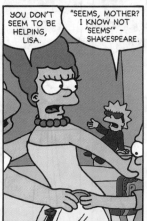

YOU DON'T SEEM TO BE HELPING, LISA.

"SEEMS, MOTHER? I KNOW NOT 'SEEMS'" - SHAKESPEARE.

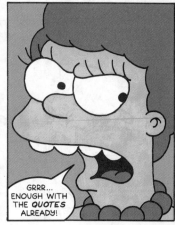

GRRR... ENOUGH WITH THE QUOTES ALREADY!

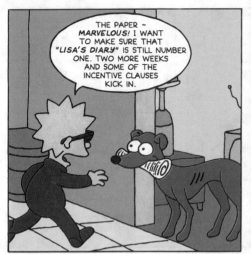

THE PAPER - *MARVELOUS!* I WANT TO MAKE SURE THAT *"LISA'S DIARY"* IS STILL NUMBER ONE. TWO MORE WEEKS AND SOME OF THE INCENTIVE CLAUSES KICK IN.

WHAT?!

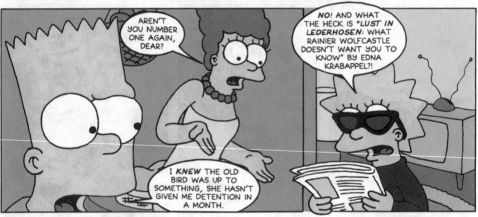

AREN'T YOU NUMBER ONE AGAIN, DEAR?

NO! AND WHAT THE HECK IS *"LUST IN LEDERHOSEN*: WHAT RAINIER WOLFCASTLE DOESN'T WANT YOU TO KNOW" BY EDNA KRABAPPEL?!

I *KNEW* THE OLD BIRD WAS UP TO SOMETHING, SHE HASN'T GIVEN ME DETENTION IN A MONTH.

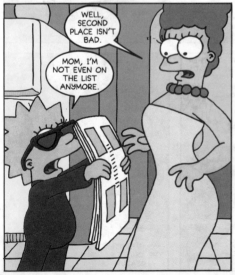

WELL, SECOND PLACE ISN'T BAD.

MOM, I'M NOT EVEN ON THE LIST ANYMORE.

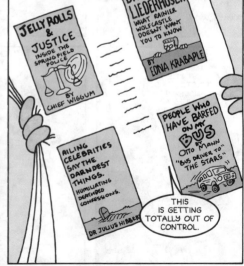

JELLY ROLLS & JUSTICE
INSIDE THE SPRINGFIELD POLICE
BY CHIEF WIGGUM

LIEDERHOSEN
WHAT RAINIER WOLFCASTLE DOESN'T WANT YOU TO KNOW
BY EDNA KRABAPLE

AILING CELEBRITIES SAY THE DARNDEST THINGS.
HUMILIATING DEATHBED CONFESSIONS.
DR JULIUS HIBBERT

PEOPLE WHO HAVE BARFED ON MY BUS
BY OTTO MANN
"BUS DRIVER TO THE STARS"

THIS IS GETTING TOTALLY OUT OF CONTROL.

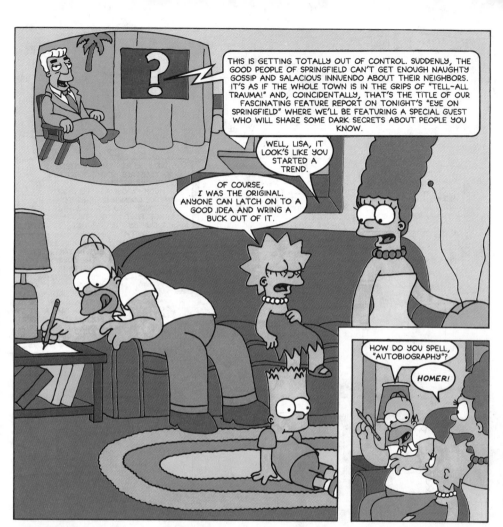

THIS IS GETTING TOTALLY OUT OF CONTROL. SUDDENLY, THE GOOD PEOPLE OF SPRINGFIELD CAN'T GET ENOUGH NAUGHTY GOSSIP AND SALACIOUS INNUENDO ABOUT THEIR NEIGHBORS. IT'S AS IF THE WHOLE TOWN IS IN THE GRIPS OF "TELL-ALL TRAUMA!" AND, COINCIDENTALLY, THAT'S THE TITLE OF OUR FASCINATING FEATURE REPORT ON TONIGHT'S "EYE ON SPRINGFIELD" WHERE WE'LL BE FEATURING A SPECIAL GUEST WHO WILL SHARE SOME DARK SECRETS ABOUT PEOPLE YOU KNOW.

WELL, LISA, IT LOOK'S LIKE YOU STARTED A TREND.

OF COURSE, *I* WAS THE ORIGINAL. ANYONE CAN LATCH ON TO A GOOD IDEA AND WRING A BUCK OUT OF IT.

HOW DO YOU SPELL, "AUTOBIOGRAPHY"?

HOMER!

PUT THAT AWAY AND WATCH THE SHOW, HOMER.

OH, I'M *SORRY*, MARGE. WHEN YOU SAID, "*HOMER*," I THOUGHT YOU WERE TALKING TO THAT FAMOUS *GREEK GUY*.

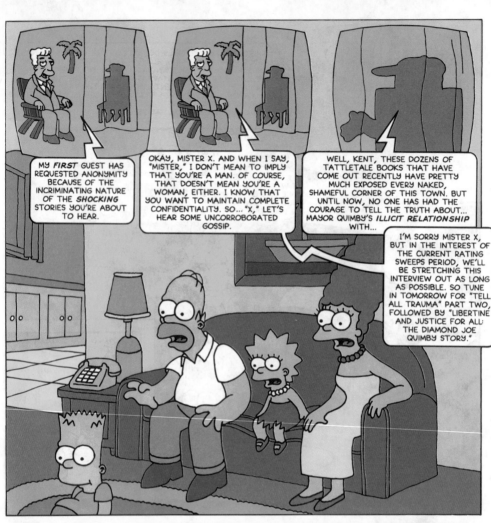

MY *FIRST* GUEST HAS REQUESTED ANONYMITY BECAUSE OF THE INCRIMINATING NATURE OF THE *SHOCKING* STORIES YOU'RE ABOUT TO HEAR.

OKAY, MISTER X. AND WHEN I SAY, "MISTER," I DON'T MEAN TO IMPLY THAT YOU'RE A MAN. OF COURSE, THAT DOESN'T MEAN YOU'RE A WOMAN, EITHER. I KNOW THAT YOU WANT TO MAINTAIN COMPLETE CONFIDENTIALITY. SO... "X," LET'S HEAR SOME UNCORROBORATED GOSSIP.

WELL, KENT, THESE DOZENS OF TATTLETALE BOOKS THAT HAVE COME OUT RECENTLY HAVE PRETTY MUCH EXPOSED EVERY NAKED, SHAMEFUL CORNER OF THIS TOWN. BUT UNTIL NOW, NO ONE HAS HAD THE COURAGE TO TELL THE TRUTH ABOUT... MAYOR QUIMBY'S *ILLICIT RELATIONSHIP* WITH...

I'M SORRY MISTER X, BUT IN THE INTEREST OF THE CURRENT RATING SWEEPS PERIOD, WE'LL BE STRETCHING THIS INTERVIEW OUT AS LONG AS POSSIBLE. SO TUNE IN TOMORROW FOR "TELL ALL TRAUMA" PART TWO, FOLLOWED BY "LIBERTINE AND JUSTICE FOR ALL: THE DIAMOND JOE QUIMBY STORY."

I CAN'T *BELIEVE* IT...

A POLITICIAN INVOLVED IN A SEX SCANDAL? ¡YAWN¡ STOP THE PRESSES.

HEY, WASN'T FAITHFULNESS TO HIS WIFE PART OF QUIMBY'S "CONTRACT WITH SPRINGFIELD"?

I'VE HAD JUST ABOUT ENOUGH OF THIS IRRESPONSIBLE GOSSIP. HOMER, CHANGE THE CHANNEL!

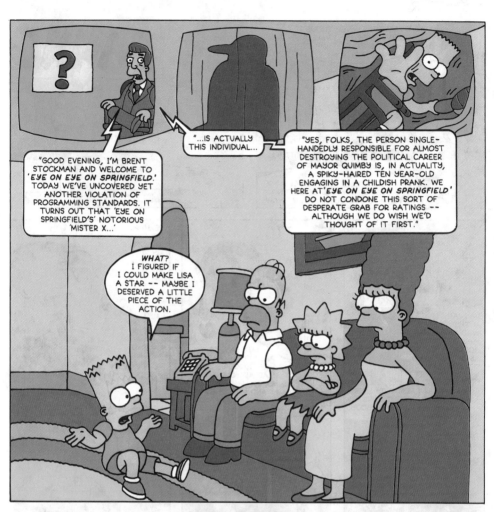

"GOOD EVENING, I'M BRENT STOCKMAN AND WELCOME TO *'EYE ON EYE ON SPRINGFIELD.'* TODAY WE'VE UNCOVERED YET ANOTHER VIOLATION OF PROGRAMMING STANDARDS. IT TURNS OUT THAT 'EYE ON SPRINGFIELD'S' NOTORIOUS 'MISTER X...'

"...IS ACTUALLY THIS INDIVIDUAL...

"YES, FOLKS, THE PERSON SINGLE-HANDEDLY RESPONSIBLE FOR ALMOST DESTROYING THE POLITICAL CAREER OF MAYOR QUIMBY IS, IN ACTUALITY, A SPIKY-HAIRED TEN YEAR-OLD ENGAGING IN A CHILDISH PRANK. WE HERE AT *'EYE ON EYE ON SPRINGFIELD'* DO NOT CONDONE THIS SORT OF DESPERATE GRAB FOR RATINGS -- ALTHOUGH WE DO WISH WE'D THOUGHT OF IT FIRST."

WHAT? I FIGURED IF I COULD MAKE LISA A STAR -- MAYBE I DESERVED A LITTLE PIECE OF THE ACTION.

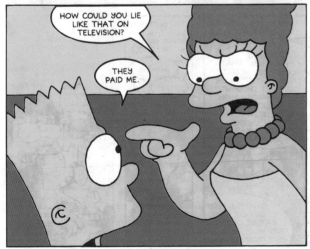

HOW COULD YOU LIE LIKE THAT ON TELEVISION?

THEY PAID ME.

HOW MUCH?

HOMER!

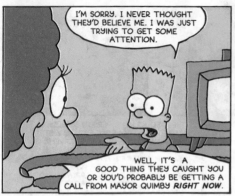

I'M SORRY. I NEVER THOUGHT THEY'D BELIEVE ME. I WAS JUST TRYING TO GET SOME ATTENTION.

WELL, IT'S A GOOD THING THEY CAUGHT YOU OR YOU'D PROBABLY BE GETTING A CALL FROM MAYOR QUIMBY *RIGHT NOW*.

RIIIING

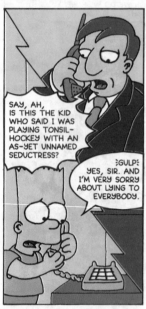

SAY, AH, IS THIS THE KID WHO SAID I WAS PLAYING TONSIL-HOCKEY WITH AN AS-YET UNNAMED SEDUCTRESS?

{GULP} YES, SIR. AND I'M VERY SORRY ABOUT LYING TO EVERYBODY.

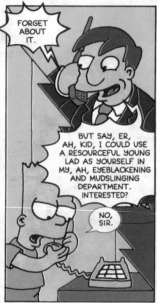

FORGET ABOUT IT.

BUT SAY, ER, AH, KID, I COULD USE A RESOURCEFUL YOUNG LAD AS YOURSELF IN MY, AH, EYEBLACKENING AND MUDSLINGING DEPARTMENT. INTERESTED?

NO, SIR.

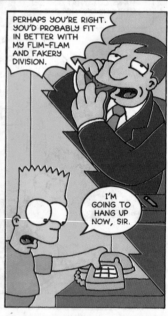

PERHAPS YOU'RE RIGHT. YOU'D PROBABLY FIT IN BETTER WITH MY FLIM-FLAM AND FAKERY DIVISION.

I'M GOING TO HANG UP NOW, SIR.

I'M SORRY. I'LL NEVER LIE AGAIN... PROBABLY.

AS A MATTER OF FACT, I'M STARTING TO FEEL A LITTLE GUILTY MYSELF. I MEAN, ALL THOSE PEOPLE WHO BOUGHT MY BOOK BELIEVE IN ME. BUT HALF THE STUFF IN THERE WAS TOTALLY MADE UP -- EVEN SOME OF THE STUFF BART DIDN'T ADD.

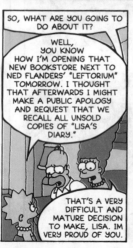

SO, WHAT ARE YOU GOING TO DO ABOUT IT?

WELL, YOU KNOW HOW I'M OPENING THAT NEW BOOKSTORE NEXT TO NED FLANDERS' "LEFTORIUM" TOMORROW. I THOUGHT THAT AFTERWARDS I MIGHT MAKE A PUBLIC APOLOGY AND REQUEST THAT WE RECALL ALL UNSOLD COPIES OF "LISA'S DIARY."

THAT'S A VERY DIFFICULT AND MATURE DECISION TO MAKE, LISA. IM VERY PROUD OF YOU.

COULDN'T YOU WAIT UNTIL AFTER WE PUT IN THE POOL?

HOMER!

D'OH!

HE'S PROUD OF YOU TOO, DEAR.

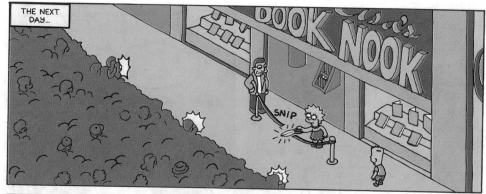
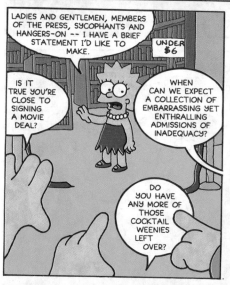
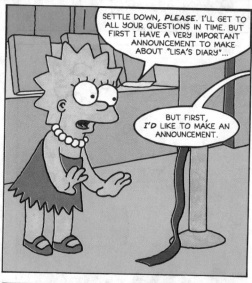
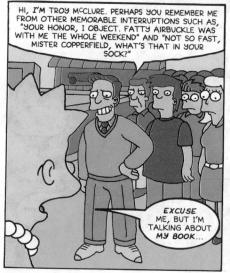

THAT'S RIGHT, FOLKS. "LISA'S DIARY" IS ACTUALLY AN ILLEGALLY PLAGIARIZED COPY OF MY OWN LIFE STORY, TENTATIVELY TITLED, "THE DEMURE McCLURE."

THAT'S RIDICULOUS. IT'S A LITTLE GIRL'S DIARY.

BACK OFF, SIMPSON. WE'RE SICK OF LABELS.

YEAH, STOP TRYING TO PIGEON-HOLE CREATIVITY.

AND, BESIDES, WHO WOULD MAKE UP A STORY LIKE THAT UNLESS IT WAS A DESPERATE ATTEMPT FOR PUBLICITY TO FLAME THE DYING EMBERS OF A STAGNANT CAREER?

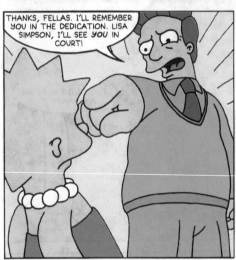

THANKS, FELLAS. I'LL REMEMBER YOU IN THE DEDICATION. LISA SIMPSON, I'LL SEE YOU IN COURT!

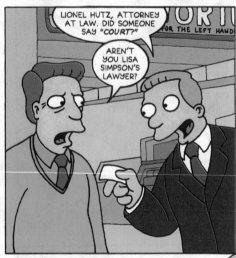

LIONEL HUTZ, ATTORNEY AT LAW. DID SOMEONE SAY "COURT"?

AREN'T YOU LISA SIMPSON'S LAWYER?

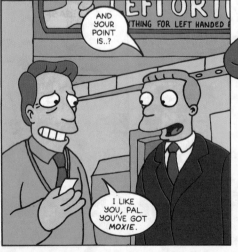

AND YOUR POINT IS..?

I LIKE YOU, PAL. YOU'VE GOT MOXIE.

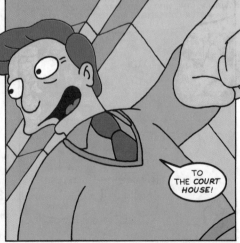

TO THE COURT HOUSE!

I THINK THAT I AM NOW, OFFICIALLY, IN OVER MY HEAD.

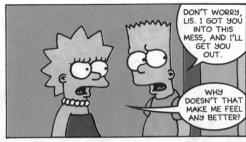

DON'T WORRY, LIS. I GOT YOU INTO THIS MESS, AND I'LL GET YOU OUT.

WHY DOESN'T THAT MAKE ME FEEL ANY BETTER?

AT THE COURTHOUSE...

YOUR HONOR, LISA SIMPSON IS A CHARMING, HARD-WORKING YOUNG GIRL...

OBJECTION -- *PREJUDICIAL*. ALLOW ME TO RESTATE...

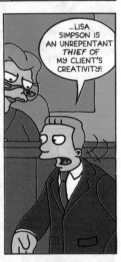

...LISA SIMPSON IS AN UNREPENTANT *THIEF* OF MY CLIENT'S CREATIVITY!

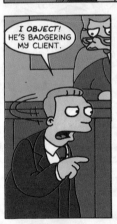

I OBJECT! HE'S BADGERING MY CLIENT.

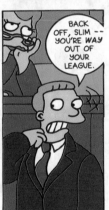

BACK OFF, SLIM -- YOU'RE *WAY* OUT OF YOUR LEAGUE.

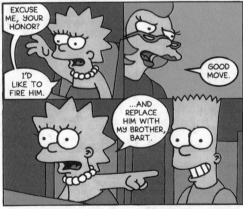

EXCUSE ME, YOUR HONOR?

I'D LIKE TO FIRE HIM.

GOOD MOVE.

...AND REPLACE HIM WITH MY BROTHER, BART.

NOT SO SMART. BUT I'LL ALLOW IT.

THANK YOU. THAT MAKES MY JOB *INFINITELY* EASIER.

LADIES AND GENTLEMEN, LISA SIMPSON CANNOT BE TRUSTED! SHE LIED TO *YOU*, SHE LIED TO *HER FAMILY*, AND MOST IMPORTANTLY, SHE LIED TO *ME!*

REALLY, YOUR HONOR, I HAD NO IDEA SHE PLAGIARIZED THE BOOK. YOU'VE GOT TO BELIEVE ME.

THAT'S ENOUGH. I WILL NOW HEAR THE SIMPSON DEFENSE.

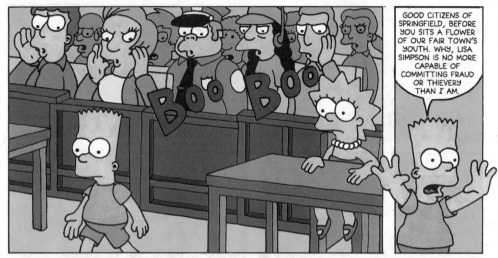

GOOD CITIZENS OF SPRINGFIELD, BEFORE YOU SITS A FLOWER OF OUR FAIR TOWN'S YOUTH. WHY, LISA SIMPSON IS NO MORE CAPABLE OF COMMITTING FRAUD OR THIEVERY THAN *I* AM.

BOO BOO

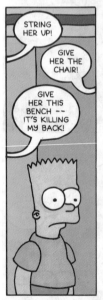

STRING HER UP!

GIVE HER THE CHAIR!

GIVE HER THIS BENCH -- IT'S KILLING MY BACK!

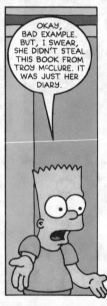

OKAY, BAD EXAMPLE. BUT, I SWEAR, SHE DIDN'T STEAL THIS BOOK FROM TROY MCCLURE. IT WAS JUST HER DIARY.

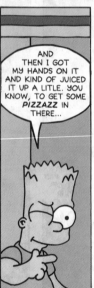

AND THEN I GOT MY HANDS ON IT AND KIND OF JUICED IT UP A LITLE. YOU KNOW, TO GET SOME *PIZZAZZ* IN THERE...

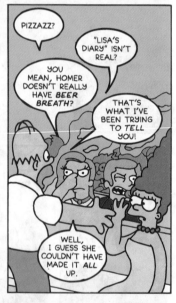

PIZZAZZ?

"LISA'S DIARY" ISN'T *REAL*?

YOU MEAN, HOMER DOESN'T REALLY HAVE *BEER BREATH*?

THAT'S WHAT I'VE BEEN TRYING TO *TELL* YOU!

WELL, I GUESS SHE COULDN'T HAVE MADE IT *ALL* UP.

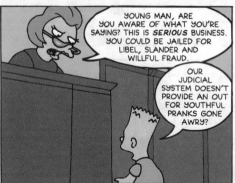

YOUNG MAN, ARE YOU AWARE OF WHAT YOU'RE SAYING? THIS IS *SERIOUS* BUSINESS. YOU COULD BE JAILED FOR LIBEL, SLANDER AND WILLFUL FRAUD.

OUR JUDICIAL SYSTEM DOESN'T PROVIDE AN OUT FOR YOUTHFUL PRANKS GONE AWRY?

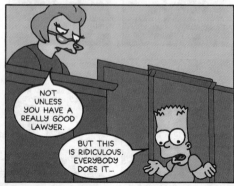

NOT UNLESS YOU HAVE A REALLY GOOD LAWYER.

BUT THIS IS RIDICULOUS. EVERYBODY DOES IT...

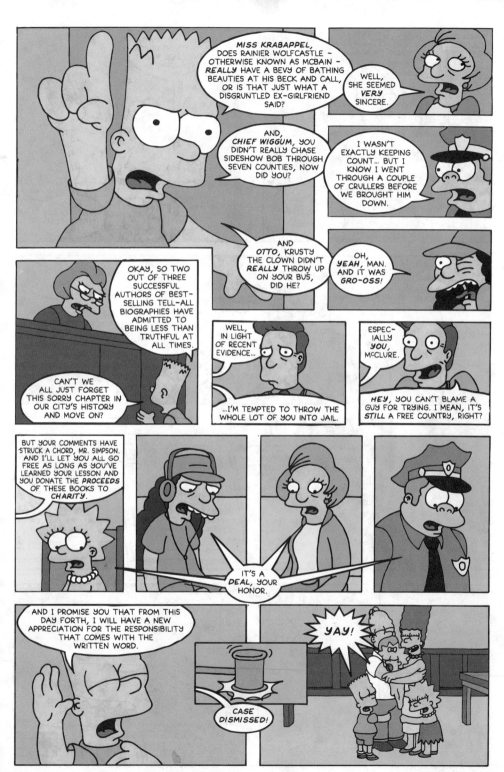

MISS KRABAPPEL, DOES RAINIER WOLFCASTLE – OTHERWISE KNOWN AS MCBAIN – *REALLY* HAVE A BEVY OF BATHING BEAUTIES AT HIS BECK AND CALL, OR IS THAT JUST WHAT A DISGRUNTLED EX-GIRLFRIEND SAID?

WELL, SHE SEEMED *VERY* SINCERE.

AND, *CHIEF WIGGUM*, YOU DIDN'T REALLY CHASE SIDESHOW BOB THROUGH SEVEN COUNTIES, NOW DID YOU?

I WASN'T EXACTLY KEEPING COUNT... BUT I KNOW I WENT THROUGH A COUPLE OF CRULLERS BEFORE WE BROUGHT HIM DOWN.

AND *OTTO*, KRUSTY THE CLOWN DIDN'T *REALLY* THROW UP ON YOUR BUS, DID HE?

OH, *YEAH*, MAN. AND IT WAS *GRO-OSS!*

OKAY, SO TWO OUT OF THREE SUCCESSFUL AUTHORS OF BEST-SELLING TELL-ALL BIOGRAPHIES HAVE ADMITTED TO BEING LESS THAN TRUTHFUL AT ALL TIMES.

WELL, IN LIGHT OF RECENT EVIDENCE...

...I'M TEMPTED TO THROW THE WHOLE LOT OF YOU INTO JAIL.

ESPEC-IALLY *YOU*, MCCLURE.

CAN'T WE ALL JUST FORGET THIS SORRY CHAPTER IN OUR CITY'S HISTORY AND MOVE ON?

HEY, YOU CAN'T BLAME A GUY FOR TRYING. I MEAN, IT'S *STILL* A FREE COUNTRY, RIGHT?

BUT YOUR COMMENTS HAVE STRUCK A CHORD, MR. SIMPSON. AND I'LL LET YOU ALL GO FREE AS LONG AS YOU'VE LEARNED YOUR LESSON AND YOU DONATE THE *PROCEEDS* OF THESE BOOKS TO *CHARITY*.

IT'S A *DEAL*, YOUR HONOR.

AND I PROMISE YOU THAT FROM THIS DAY FORTH, I WILL HAVE A NEW APPRECIATION FOR THE RESPONSIBILITY THAT COMES WITH THE WRITTEN WORD.

YAY!

CASE DISMISSED!

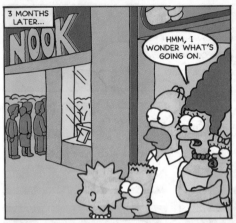

3 MONTHS LATER...

NOOK

HMM, I WONDER WHAT'S GOING ON.

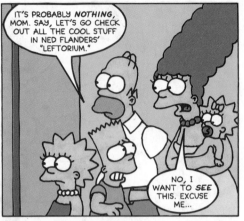

IT'S PROBABLY *NOTHING*, MOM. SAY, LET'S GO CHECK OUT ALL THE COOL STUFF IN NED FLANDERS' "LEFTORIUM."

NO, I WANT TO *SEE* THIS. EXCUSE ME...

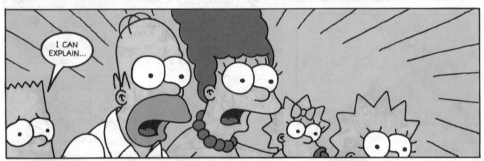

I CAN EXPLAIN...

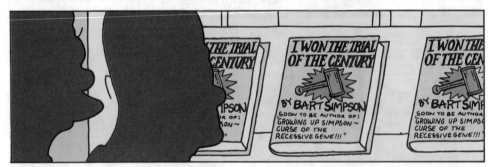

I WON THE TRIAL OF THE CENTURY

I WON THE TRIAL OF THE CENTURY
BY BART SIMPSON
SOON TO BE AUTHOR OF: "GROWING UP SIMPSON ~ CURSE OF THE RECESSIVE GENE!!!"

I WON THE TRIAL OF THE CEN
BY BART SIMP
SOON TO BE AUTHOR "GROWING UP SIMPS CURSE OF THE RECESSIVE GENE!!!

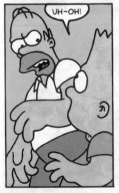

UH-OH!

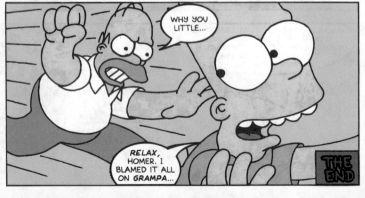

WHY YOU LITTLE...

RELAX, HOMER. I BLAMED IT ALL ON *GRAMPA*...

THE END

118

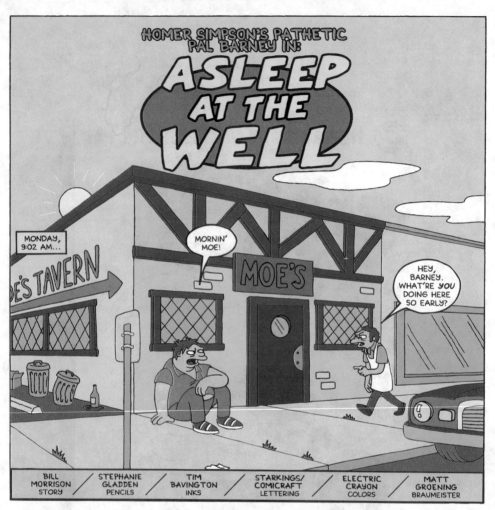

HOMER SIMPSON'S PATHETIC PAL BARNEY IN:

ASLEEP AT THE WELL

MONDAY, 9:02 AM...

MORNIN' MOE!

HEY, BARNEY. WHAT'RE *YOU* DOING HERE SO EARLY?

MOE'S TAVERN

MOE'S

| BILL MORRISON STORY | STEPHANIE GLADDEN PENCILS | TIM BAVINGTON INKS | STARKINGS/ COMICRAFT LETTERING | ELECTRIC CRAYON COLORS | MATT GROENING BRAUMEISTER |

MY NEW ROOMMATE THREW A *WILD PARTY* AT OUR APARTMENT LAST NIGHT. IT WAS SO *NOISY* THERE, I COULDN'T FALL ASLEEP...

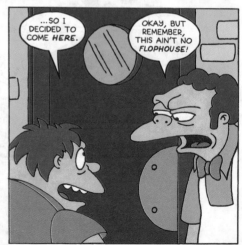

...SO I DECIDED TO COME *HERE.*

OKAY, BUT REMEMBER, THIS AIN'T NO *FLOPHOUSE!*

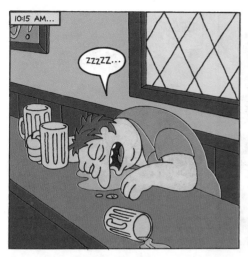

10:15 AM...

ZZZZZ...

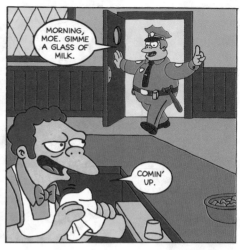

MORNING, MOE. GIMME A GLASS OF MILK.

COMIN' UP.

GULP!

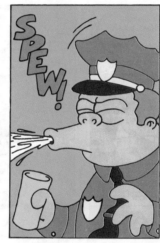

SPEW!

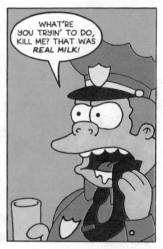

WHAT'RE YOU TRYIN' TO DO, KILL ME? THAT WAS *REAL MILK!*

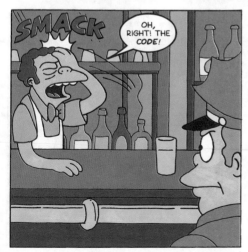

SMACK

OH, RIGHT! THE *CODE!*

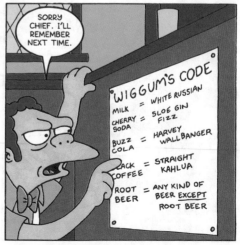

SORRY CHIEF. I'LL REMEMBER NEXT TIME.

WIGGUM'S CODE

MILK = WHITE RUSSIAN

CHERRY SODA = SLOE GIN FIZZ

BUZZ COLA = HARVEY WALLBANGER

BLACK COFFEE = STRAIGHT KAHLUA

ROOT BEER = ANY KIND OF BEER EXCEPT ROOT BEER

11:35 AM...

ZZZZZ...

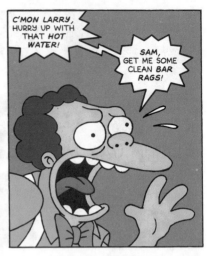

C'MON LARRY, HURRY UP WITH THAT *HOT* WATER!

SAM, GET ME SOME CLEAN *BAR* RAGS!

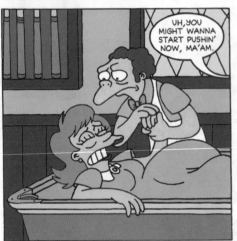

UH, YOU MIGHT WANNA START PUSHIN' NOW, MA'AM.

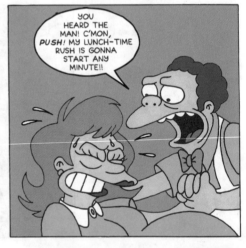

YOU HEARD THE MAN! C'MON, *PUSH!* MY LUNCH-TIME RUSH IS GONNA START ANY MINUTE!!

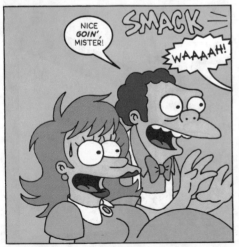

NICE *GOIN'*, MISTER!

SMACK

WAAAAH!

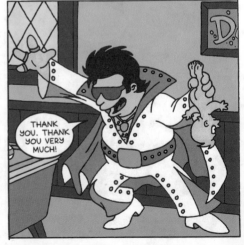

THANK YOU. THANK YOU VERY MUCH!

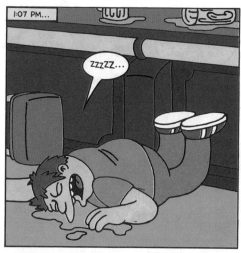

1:07 PM...

ZZZZZ...

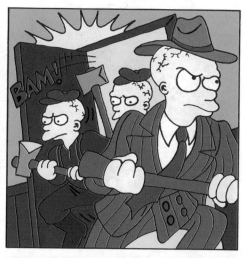

BAM!!

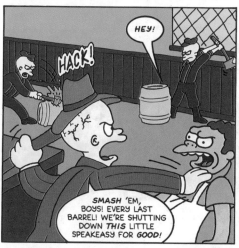

HACK!

HEY!

SMASH 'EM, BOYS! EVERY LAST BARREL! WE'RE SHUTTING DOWN *THIS* LITTLE SPEAKEASY FOR *GOOD!*

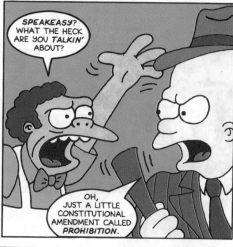

SPEAKEASY? WHAT THE HECK ARE YOU *TALKIN'* ABOUT?

OH, JUST A LITTLE CONSTITUTIONAL AMENDMENT CALLED *PROHIBITION.*

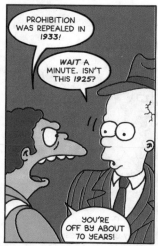

PROHIBITION WAS REPEALED IN 1933!

WAIT A MINUTE. ISN'T THIS *1925?*

YOU'RE OFF BY ABOUT 70 YEARS!

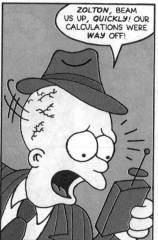

ZOLTON, BEAM US UP, *QUICKLY!* OUR CALCULATIONS WERE *WAY* OFF!

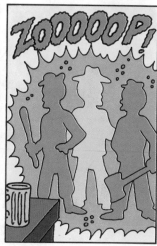

ZOOOOOP!

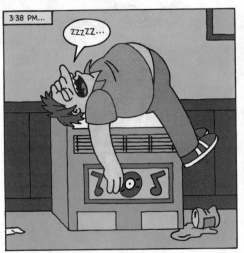

3:38 PM...

ZZZZZ...

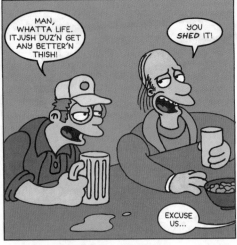

MAN, WHATTA LIFE. ITJUSH DUZ'N GET ANY BETTER'N THISH!

YOU *SHED* IT!

EXCUSE US...

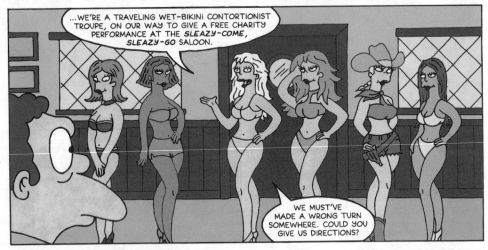

...WE'RE A TRAVELING WET-BIKINI CONTORTIONIST TROUPE, ON OUR WAY TO GIVE A FREE CHARITY PERFORMANCE AT THE *SLEAZY-COME, SLEAZY-GO* SALOON.

WE MUST'VE MADE A WRONG TURN SOMEWHERE. COULD YOU GIVE US DIRECTIONS?

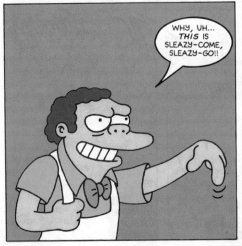

WHY, UH... *THIS* IS SLEAZY-COME, SLEAZY-GO!!

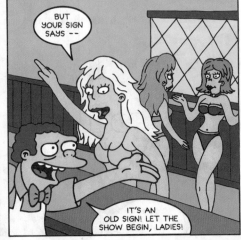

BUT YOUR SIGN SAYS --

IT'S AN OLD SIGN! LET THE SHOW BEGIN, LADIES!

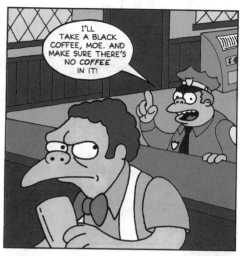

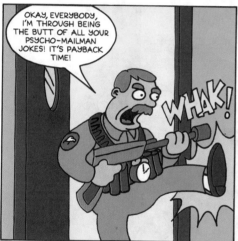

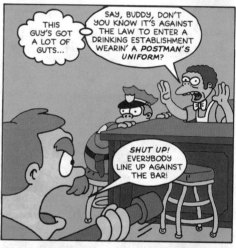

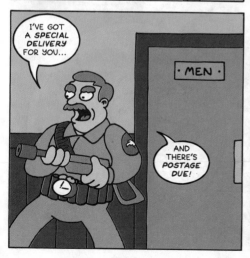

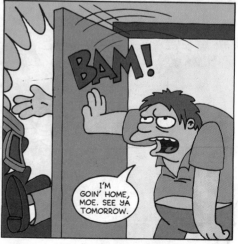